IMAGES
of England

CHELTENHAM

This book is dedicated to the memory of my parents,
Iris and Bill Worsfold

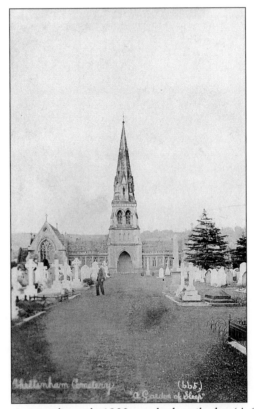

Cheltenham cemetery in the early 1900s, aptly described as 'A Garden of Sleep'.
The cemetery, in Priors Road, was opened in 1864.

IMAGES
of England

CHELTENHAM

Compiled by
Elaine Heasman

TEMPUS

First published 1998
Copyright © Elaine Heasman, 1998

Tempus Publishing Limited
The Mill, Brimscombe Port,
Stroud, Gloucestershire, GL5 2QG

ISBN 0 7524 1145 4

Typesetting and origination by
Tempus Publishing Limited
Printed in Great Britain by
Midway Clark Printing, Wiltshire

*For each copy of this book sold, the author will donate fifty pence
to the Cheltenham Cobalt Unit Appeal*

Also available from Tempus Publishing:

Barnwood, Hucclecote and Brockworth
Chalford to Sapperton
Churchdown
Forest to Severn
Forest Voices
Filton and the Flying Machine
Gloster Aircraft Company
The City of Gloucester
Knowle and Totterdown
Around Nailsworth and Minchinhampton
Around Newent
Painswick, Sheepscombe, Slad and Edge
Stonehouse, the Stanleys and Selsey
Pubs of the Old Stroud Brewery
Stroud: Five Stroud Photographers
The Wildfowl and Wetlands Trust

Contents

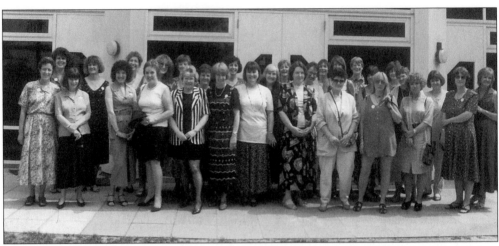

Former Pate's Grammar School pupils travelled from all over the British Isles for this reunion, held in Cheltenham, in 1995. Photographs were exchanged and yesterdays at Pate's, between 1958 and 1965, remembered.

Introduction

How diligently must we strive to hand over undiminished to those who come after us the heritage that we have received from our fathers.

These words were written in the nineteenth century by Major Robert Cary Barnard (1827-1906), in his book *Records of Leckhampton*. In compiling this book on Cheltenham I have come to realise what it was that my parents came to know and love about the town. Furthermore, I have begun to apprehend the responsibility that each and every one of us has to safeguard that which we value today for the next generation.

This is not a history book but rather a book with history in it. When I began to compile this book, I soon realised that I knew very little about Cheltenham, despite having been born here. I imagine that I was taught some local history in my schooldays but I am sorry to say that I remember very little of this. I am not alone in this discovery: many local people who I have spoken to agree that they too have been guilty of walking around with their eyes closed. Possibly, it is only when asked to see the town from the perspective of the visitor, that one starts to fully appreciate what it is we have here.

However, Cheltenham people need no prompting to talk about their yesterdays. Invariably, the memories are good ones. Schooldays are normally remembered as happy times and common childhood recollections include visits to the town's numerous parks and gardens and time spent exploring Cleeve and Leckhampton Hills.

The attraction of this *Archive Photograph Series*, for many, must be the excitement of seeing things as they used to be, remembering shops that have long since changed hands and recognising a well-loved face from the past. It is this mix of people and places that I have always liked in collections such as this and, hopefully, my selection of material for this volume will give pleasure to many readers of all ages and from all walks of life.

The book is divided into geographical areas for ease of reference and as a guide to those readers with an interest in a particular area. I must apologise that

the boundaries of each chapter may seem rather loosely defined, but in some instances I found that the photographs and cards tended to naturally fall into groups of their own. It will be evident to the reader that not all areas of Cheltenham are represented in this book. There is no shortage of material, merely a lack of space. I am hoping that this volume will be the first of many and therefore extend an invitation for anyone to contact me if they have items which they feel would be of interest to include in a later publication.

I have exhausted the local libraries in my quest to find background information for the images included here and feel indebted to anyone who has ever written anything about Cheltenham. The *Kelly's Directories* have been an enormous help and I have the greatest admiration for whoever had the foresight to realise the value of such a record of Cheltenham and its people. I would like to thank my family and friends, who have loaned photographs and postcards, and also the lovely people Geoff and I have met whilst researching the book – who have willingly given their time and made me feel that the effort has been worthwhile. Finally, my thanks to Geoff, who always believed that I could, and should, compile this book.

Having now revisited Cheltenham with a more critical eye, my feelings are mixed. I am sad that we are still allowing some of our fine old properties to be demolished: for example, only recently the Malvern Inn has disappeared as a landmark in the Leckhampton Road. Furthermore, some parts of Cheltenham, of which I feel we should be immensely proud, are looking decidedly unloved and even dilapidated. The parish churchyard has an unwelcoming feel about it and, although admirable that some of our famous 'dragon and onion' lamp standards have been preserved here, they are in dire need of a coat of paint. On a more positive note, I have been impressed to see a number of new buildings, such as the terrace in Montpellier Spa Road, being built in the classical style of the surrounding properties.

Two memories will stay with me. The first is a little plaque beneath a young tree in Montpellier Gardens, which bears the words 'In memory of Mina Carlin died 23rd August 1985 – A Scottish lady who loved Cheltenham's trees'. Yes, our trees are indeed lovely and, sometimes, we need reminding to appreciate them. The second memory is my rediscovery of Edward Wilson, the Antarctic explorer who was born in Cheltenham. On finding a postcard featuring the statue erected in his memory in the Long Garden in the Promenade, I was reminded of visits to the museum as a young child and the fascination of looking at the Antarctic exhibits. Today, our museum is offering a similar Edward Wilson exhibition to delight another generation of children. I find I am still fascinated by stories of this local man, who was known for his strength of character, judgement and common sense. He loved life and one wonders what else he would have achieved had he not died so young. He is said to have written 'the more one does, the more one gets to do' – indeed, an aspiration to us all.

Elaine Heasman (née Worsfold), March 1998

One

The High Street

Cheltenham was a market town as far back as 1226. For years it was renowned as possessing a long main street and a market. The town developed around the lanes and alleyways of the lower end of the High Street and it was not until fifty or sixty years ago that the area known as Boot's Corner came to be considered as being the town centre.

Lots of changes have taken place over the years: many hotels and lodging houses have been demolished to make way for larger stores and shopping arcades. Numerous postcards of the High Street tell their own stories of days gone by. Surprisingly evident in these pictures are the horse-drawn delivery vehicles – this was a mode of transportation that was continued well into the 1960s.

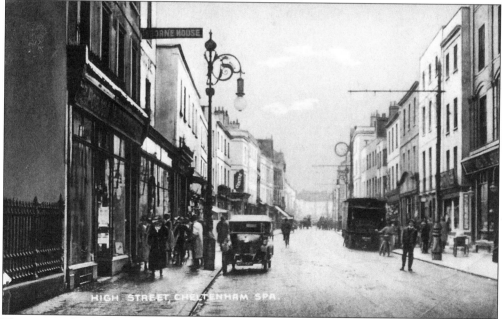

This view, which looks up the High Street, is from a postcard sent in 1928. The town clock hung from the upper storey of a building used as the Town Offices for many years. This site was later occupied by F. W. Woolworth & Co. and then Tesco's. An example of a 'dragon and onion' lamp standard can be seen to the left of the picture. These ornate lamps were designed by Mr Joseph Hall, Cheltenham's Borough Engineer for the town's new electricity supply (from 1897 onwards).

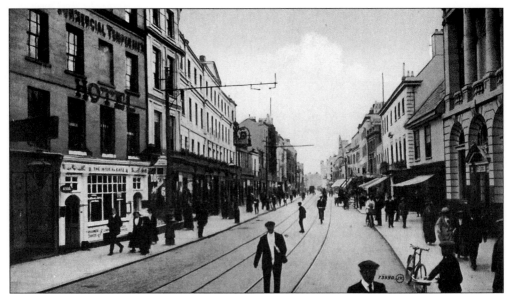

An early view of the High Street, on a postcard published by the stationery firm Dodwell & Sons. One of the early commercial hotels can be seen, on the left of the picture, above the Imperial Café.

NAME _____ Week Ending W/E Sept 4 Box No. ____

TELEPHONE 2737 CHELTENHAM (Private Branch Exchange.) MEMBERS OF THE P.W.N.A. TELEGRAMS · DODWELL, NEWSAGENT, CHELTENHAM

WAREHOUSE HOURS:—5-30 a.m. to 5 p.m. EARLY CLOSING—WEDNESDAY 1 p.m.

To

F. C. DODWELL & SONS SEPTEMBER, 1937

C. C. DODWELL AND L. A. DODWELL

WHOLESALE NEWSAGENTS BOOKSELLERS AND STATIONERS

This List must reach us by first post Thursday
FOR SUPPLIES FOR THE FOLLOWING WEEK.

CHELTENHAM SPA

X WE CANNOT GUARANTEE ALTERATIONS FROM PREVIOUS WEEKS SUPPLY IF RECEIVED LATE X

'ore you START in this order. lletins Sent for m Issues. he Newsagent" ch week e intelligence.

MONDAY — 1d.
- Home Companion .. AP
- Horner's Stories .. AP
- Bve's Own .. AP
- Miracle .. AP
- Mab's Home Weekly.. AP
- Smart Novels
- Christian Novels
- Complete Novel
- Adventure
- Lucky Star
- Guide and Ideas
- Leader
- Winner
- Everybody's Weekly
- Christian Herald

2d.
SUNDAY PAPERS (Returns Strictly Limited)
- Reynolds
- Pictorial
- Dispatch
- Graphic
- People
- Express
- Observer
- News of the World
- Times

TUESDAY
- Butterfly .. AP
- Jingles .. AP
- Church Army Gazette ½d.
- Puck .. AP
- Chick's Own .. AP
- Woman's Weekly.. AP
- Picture Show .. AP
- Triumph .. AP
- Film Fun .. AP
- Boy's Cinema .. AP
- Wizard
- Red Letter
- My Weekly
- Secrets
- Family Star
- Family Herald
- Farmer and Stock..
- Racing and Football Outlook
- Bazaar
- Racehorse
- Football Forecast
- Peg's Paper
- Amateur Gardening
- La France
- Bicycle
- Water Life

DID YOU TAKE ADVANTAGE OF OUR GENEROUS TERMS FOR ANNUALS

WEDNESDAY
- Chips .. AP
- Tip Top .. AP
- Tiger Tim .. AP
- Bubbles .. AP
- Sunday Circle .. AP
- Family Journal .. AP
- School Girl's Weekly .. AP
- Gem .. AP
- Modern Wonder
- The Cyclist
- Flame
- Hobbies
- Topical Times
- Cycling
- Farm, Field and Fireside
- Life of Faith
- Eggs
- Police News
- Agents' Journal
- Insurance Mail .. X
- National Message.. X

MISCELLANEOUS ITEMS x
Enter Here all Periodicals not Listed.

THURSDAY
- Joyful News .. x
- Children's Newspaper AP
- Tiny Tots .. AP
- Sunday Companion .. AP
- Film Pictorial .. AP
- Detective Weekly.. AP
- Sports Budget .. AP
- Woman
- The Rover
- Welcome..
- Woman's Way
- Red Star Weekly..
- John Bull
- Picturegoer
- Thomson's Weekly
- Fairyland Tales
- People's Friend
- Exchange and Mart
- Carpenter and Builder..
- New Chronicle
- Christian
- C.E. Times
- Christian World
- Pulpit (Christian World)
- Methodist Recorder
- Schoolmaster .. x
- Baptist Times .. x
- British Weekly .. x
- Guide .. x
- Methodist Times & Leader x
- Bee Journal .. x
- English Churchman .. x
- Railway Review .. x
- Psychic News .. x
- Homing World .. x
- Light .. x

FRIDAY
- Comic Cuts .. AP
- Joker .. AP
- Wonder .. AP
- Cardiff Weekly Mail
- Birmingham Weekly Post
- Public Assist. Journal ½d. x
- Radio Times..
- Rainbow.. AP
- Playbox .. AP
- Oracle .. AP
- Woman's World .. AP
- The Pilot .. AP
- Crystal .. AP
- Answers .. AP
- Woman's Illustrated .. AP
- Tit-Bits
- Woman's Way
- John o' London
- Pearson's Weekly
- Betty's Paper..
- Passing Show
- Humorist
- Woman's Own
- Lady's Companion
- World Radio
- Hotspur
- Mickey Mouse
- Weekly Illustrated .. X
- Office Training .. X
- Journal of Business Ed. X
- Church of England News
- Manchester Guardian Wkly.
- Specialist
- Home Gardening..
- Smallholder
- Farmers' Weekly
- Church Times
- Cage Birds
- Guardian
- Poultry World
- Gloucester Journal

SATURDAY
- Jester .. AP
- Larks .. AP
- Jolly Comic .. AP
- Sparkler .. AP
- Crackers.. AP
- Sunbeam .. AP
- Thriller .. AP
- Champion .. AP
- Woman's Companion .. AP
- Magnet .. AP
- Popular Gardening .. AP
- School Girl .. AP
- Sunday Stories .. AP
- Modern Boy..
- Home Chat .. AP
- Weekly Telegraph
- Skipper ..
- News of the World
- Home Notes..
- Woman's Friend ..
- Sporting Chron. H'cap..
- Sporting Life Weekly..
- Reynold's
- Motor Transport..
- Cheltenham Chronicle..
- Garden Work
- Post Magazine
- Wilts & Glos. Standard X
- Evesham Journal .. X
- Berrows Worcester Journal
- Liverpool Weekly Post X
- Greyhound Outlook .. X

The family firm of F. Dodwell & Sons was established in 1883, running both wholesale and retail operations from various premises around the town. This is an extract from an order list issued to newsagents and also used in the warehouse as an 'add and stop' record. It gives a good indication as to the size of the wholesale business. Attention to customer service seems to have been of paramount importance in 1937. Dodwell's advises the customer to make 'ONE ORDER, ONE PARCEL, ONE CHEQUE' and 'Get ALL your supplies, WITHOUT trouble, WITH service, from DODWELLS'.

Albert Edward 'Ted' Heasman began working for Dodwell's in March 1920, in the wholesale department. He eventually became warehouse/sales manager. He is pictured here, third from the left, with other employees, Christmas 1926.

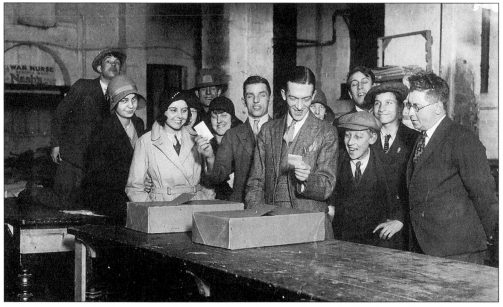

Ted Heasman is in the centre of this wartime photograph and Leslie Dodwell on the extreme right. Other employees include Ernest Jones, Ted Morris, Archie Nottingham and Miss Purnell. F. Dodwell & Sons operated as wholesale newspaper distributors from no. 333, High Street (later renumbered as 252, High Street). To the rear of this property were the warehouse buildings, which have since been demolished. The upper storey of this building is St George's Hall, which opened in 1856 as a function room and has recently been restored.

```
                    STAFF INSTRUCTIONS FOR

                        VICTORY DAY.
              --------------------------------

              The day the announcement of the cessation of Hostilities
     is issued, all shops will immediately close.

              As far as can be ascertained NEWSPAPERS WILL BE ISSUED
     AS USUAL ON VICTORY HOLIDAY, i.e. the day AFTER the announcement
     that hostilities may be considered to have ended in Europe.

              Your shop therefore will be open for the sale of news-
     papers and close at 11 a.m. or when all dailies are sold whichever
     is the earlier.

              I leave it to the manageress to decide what staff they
     shall detail for this work.

     12th April 1945.
```

Leslie A Dodwell

On 12 April 1945, Leslie Arthur Dodwell, son of Frank Charles Dodwell, issued the above instructions to his staff for Victory Day. Leslie Dodwell died later the same year and his nephew Paul Dodwell took over the running of the business.

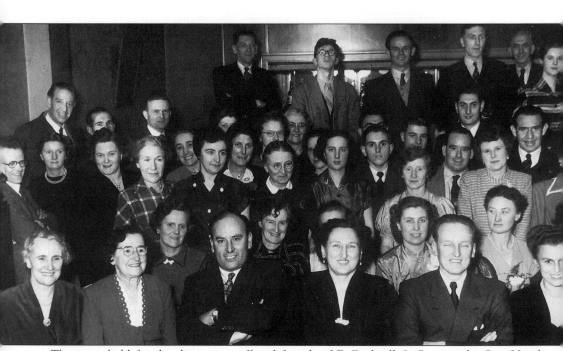

The party held for the directors, staff and friends of F. Dodwell & Sons at the Star Hotel, Regent Street, Cheltenham (now converted to J.D. Peppers), at which the presentation (above right) was made. From left to right, front row: Amy Jenkins, Mabel Dodwell, Michael Dimmer, Janet Dimmer, Paul Dodwell, Joyce Dodwell (née Poulton), Kenneth Dodwell, Betty Dodwell

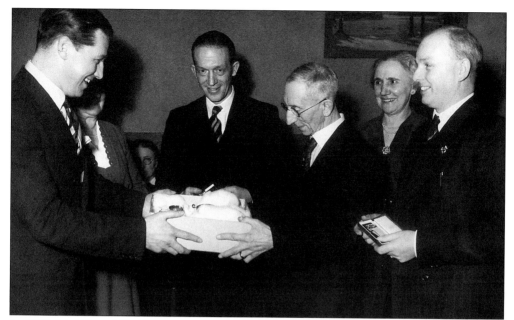

In 1954, Mr Edward G. Clare was presented with a silver tea service by Mr Kenneth Dodwell, grandson of Mr F. Dodwell, to mark forty-two years of service with the firm. Also in this picture are, from left to right: Miss Mabel Dodwell, Mr Ted Heasman, Miss Amy L. Jenkins and Mr Archie S. Nottingham, who received gold watches for their service of thirty, thirty-three, twenty-four and thirty-two years, respectively.

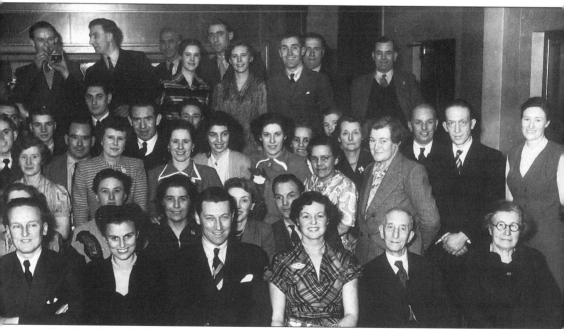

(née Hindle), Edward Clare, Gertrude Clare (née Dodwell). Also included in the group: Miss Cole, Lilian Heasman, Ted Heasman, Archie Nottingham, Joe Patrick, Joe Patrick Snr, Mrs Smith and Miss Stanbridge.

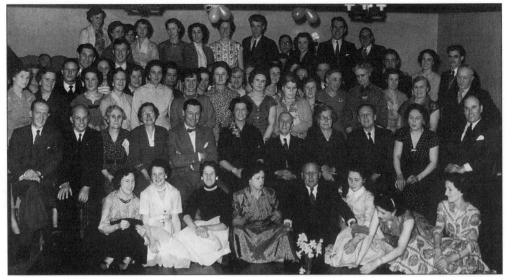

Dodwell's staff (and friends) pictured on another happy occasion. From left to right, first row (seated): Ted Heasman, Archie Nottingham, Amy Jenkins, Mabel Dodwell, Ken Dodwell, Betty Dodwell, Edward Clare, Gertrude Clare, Paul Dodwell, Janet Dimmer and Michael Dimmer. Elsewhere in the group: Miss Cole, Lilian Heasman, Ted Morris, John Sawyer, Mrs Smith and Miss Stanbridge.

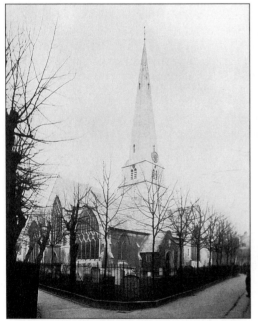

Left: St Mary's parish church, situated behind the High Street in Church Street, is Cheltenham's only medieval church. It is the oldest building in the town, dating back to the twelfth century. This postcard, printed by Norman Brothers Ltd, Bennington Street, Cheltenham, shows the church in the early 1900s with the railings around the church and graveyard clearly visible. Right: Rosemary Woodward (née Smithers) and Doreen Morrison (née Yates), apprentice hairdressers at Lorraine's, no. 200, High Street, pictured in their uniforms in St Mary's parish churchyard in 1963.

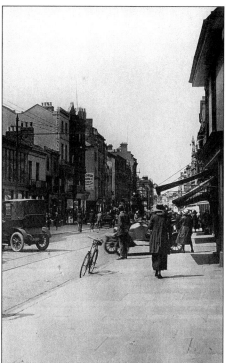

Left: October 1901 invoice from Frederick Norman, wholesale stationer and paper merchant of no. 3, Bedford Buildings, Clarence Street. Bedford Buildings was a terrace, of mainly offices and shop premises, which dated back to the early 1800s. It was situated at the junction of what are now Clarence Street and St George's Place. Right: In this busy High Street scene, the tracks for the electric trams are clearly visible and we can also see a horse-drawn carriage, bicycles and motor cars. The car on the left is probably pulling into the Plough Hotel's yard. A little further down, 'Vanderplank' is written on the side of the tall building. Vanderplank of Harrods was a well-known store, which sold fashion and furs.

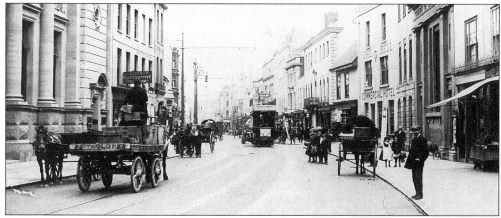

Another High Street view, from a postcard which was sent in 1905. This shows a tram and several horse-drawn carts, including one belonging to Batholomew's wine merchants. Lloyds Bank, on the left at the corner of Rodney Road, was built on the former site of the Assembly Rooms (demolished in 1900) and was completed in 1902. On the right is the County of Gloucester Bank, previously Pitt's Bank. The building was later converted and used by C&A.

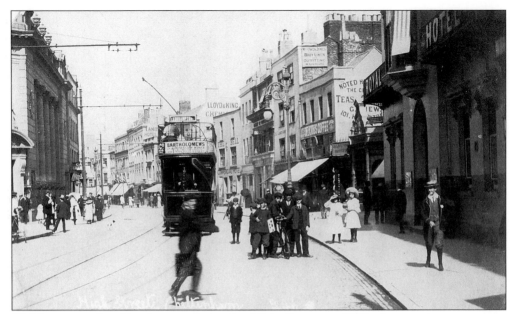

Children pose for this photograph in the High Street, *c.* 1905. A tram is en route to Leckhampton, carrying an advertisement for Batholomew's. The doorway of Lloyds Bank can be clearly seen. On the right is the Royal Hotel, which was later demolished.

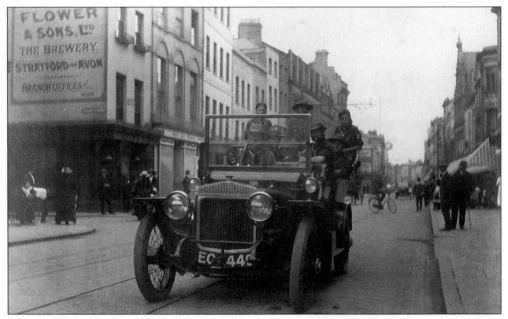

An early Daimler driving along the High Street (opposite the junction with Regent Street). The order office for the brewery, Flower & Sons, is on the corner. The town clock can be seen in the distance.

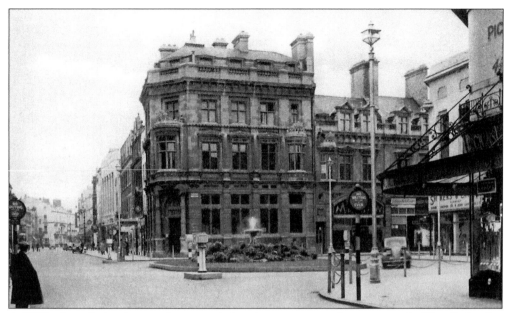

A 1940s view of what is nowadays regarded as the town centre by most people. The distinctive frontage of the Charles Dickins & Co. tobacco store (established 1889), can be seen on the right of the picture. The elaborate canopy was made by Charles William Hancock, around 1920. Many buildings in the High Street were demolished to make way for the traffic island.

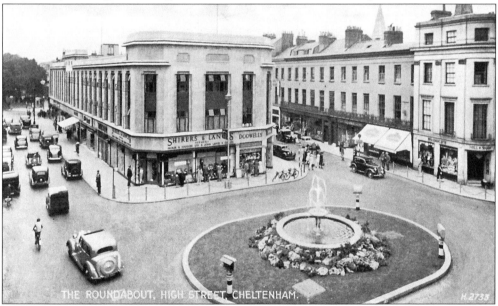

This shows the one-way movement of traffic around the Colonnade in the Promenade and Clarence Street. In 1833, two former employees of Clark & Debenham (later Cavendish House), Messrs Alexander Shirer and Donald MacDougal, set up in business together. John Lance & Co. was trading in the High Street in the early 1900s. When the Colonnade was rebuilt, during town centre development, these businesses amalgamated to form Shirers & Lance's, seen here at the end of the Colonnade, next to Dodwells. Sadly, the firm closed in 1979.

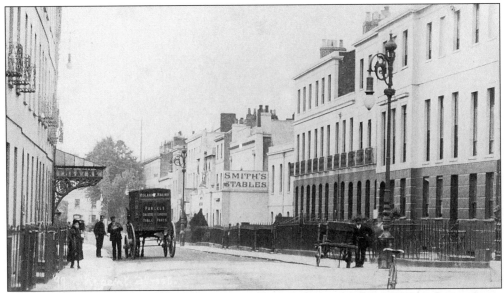

Regent Street, early 1900s. The theatre is on the left, with a Midland Railway horse-drawn delivery van outside it. Opposite is Smith's Stables, which provided the carriages for the Prince of Wales' visit in 1897. A riding school also operated from here. This site is now part of the Regent Arcade.

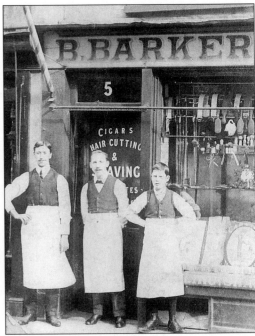

Left: The Theatre and Opera House – designed by Frank Matcham, the designer of both the London Palladium and the Bristol Hippodrome – opened in Regent Street in 1891, with a performance by Miss Lily Langtry and her company. The theatre has been known as the Everyman Theatre since 1960. Right: B. Barker's barber shop, no. 5, Winchcombe Street, *c.* 1910. The boy on the right is a young member of the Jakeway family. The buildings at this end of Winchcombe Street were demolished when the street was widened in the early 1960s.

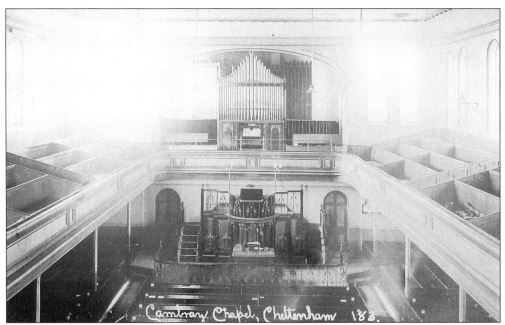

A view of the interior of Cambray Baptist chapel, Cambray Place. This was built in the 1850s, in the Italianate style, from the designs of Mr Dangerfield, the borough surveyor. At the rear of the chapel was a small schoolroom.

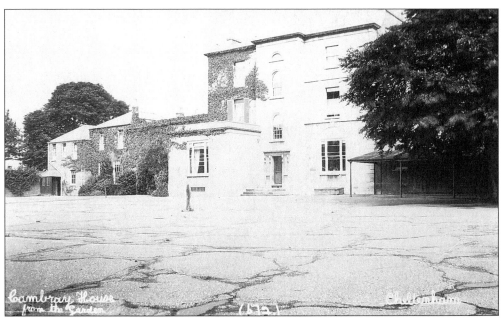

Cambray House stood on the site where Cambray Court flats now stand. The Ladies' College opened here, in February 1854, and soon came to be regarded as England's foremost school for girls. The school moved to new premises in 1873. Miss Dorothea Beale was the school's second headmistress from 1858 until 1906.

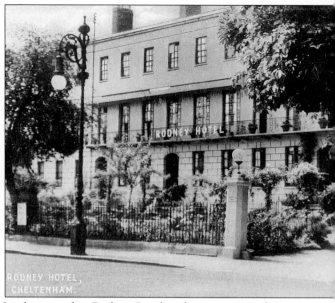

RODNEY HOTEL

(Cheltenham) Ltd.

RODNEY ROAD
CHELTENHAM SPA

The RODNEY *is a* RESIDENTIAL
HOTEL, *situated in a quiet road
in the centre of the Town*

———

MODERATE TERMS
*Tea Room—open each day including Sundays
for Morning Coffee, Lunches, Teas, Dinners
and Snacks.*
OPEN TO NON-RESIDENTS

———

Telephone
CHELTENHAM 52175

Resident Managing Director
MRS. C. E. ADCOCK (M.H.C.I.)

An advertisement for the Rodney Hotel, situated in Rodney Road at the junction with Regent Street, taken from the program for the Cheltenham Music Competitive Festival in 1961. This end of the terrace in Rodney Road was demolished and partly rebuilt when the Regent Arcade and a car park were built in the 1980s.

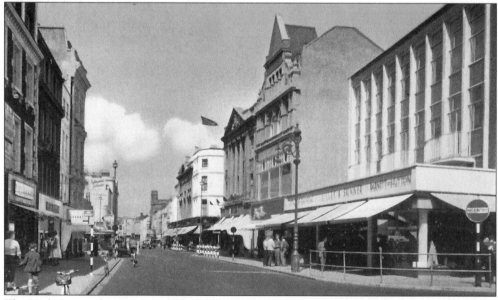

The High Street, showing E. L. Ward's department store occupying several shops at the corner of North Street. This store opened in 1901 and closed in 1967. The present-day Littlewood's store was built on the site. In Ward's, all money was handled in an upstairs office. The customer's cash was placed in a container, which was sent up via a series of pulleys. Sometime later, as if by magic, the change appeared by the same method.

Two
The Promenade

The Colonnade was originally a row of shops, built on the south side of the High Street between 1791 and 1794. It was extended southwards in 1817 and 1818 to connect the Imperial Spa, on the present day site of the Queen's Hotel, with the High Street. This quarter-mile stretch was lined with forty-four chestnut trees and became known as the Promenade.

During the early part of the nineteenth century, many private residences were built here. Gradually these buildings have been converted into shops or offices. Most Cheltenham guidebooks boast photographs of the Promenade to attract visitors to the town. Apart from the increase in traffic and the change in use, or actual demolition, of some of the properties, the Promenade has changed little over the years and retains much of its original beauty and charm.

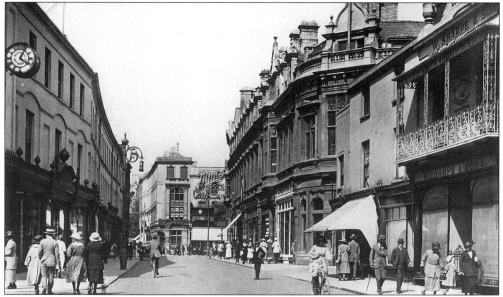

When this photograph was taken, Boot's Chemists had not yet expanded to occupy the building on the corner of North Street and traffic was running both ways along the Colonnade and through to the Promenade. The balcony of W. Sharpe & Sons, on the right of the photograph, is a fine example of Cheltenham's decorative ironwork. The ornate shopfront on the left, beneath the clock, belongs to Martin & Co, jewellers, who were established in 1806. In 1933, this company secured the permanent contract to supply the trophy that is annually presented to the winner of the Cheltenham Gold Cup Steeplechase at Prestbury Park.

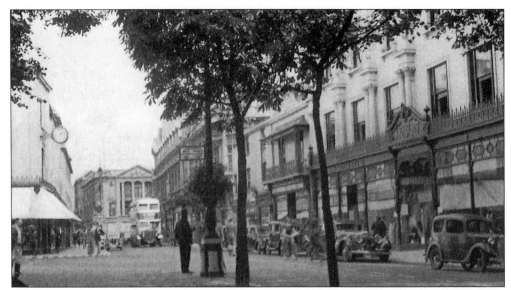

Cheltenham acquired its first totally enclosed double-decker buses in 1934. One of these buses is seen here travelling towards the Promenade. The one-way system through the Colonnade is clearly in operation. On the right of the photograph is Cavendish House, still with its original façade.

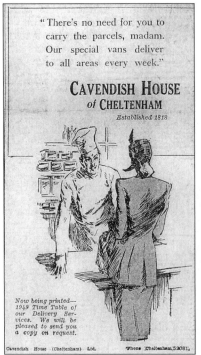

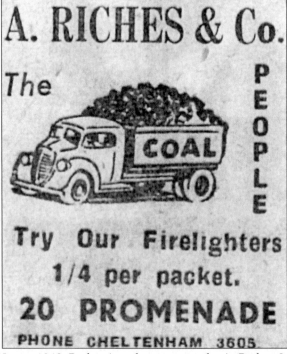

Left: An advertisement for Cavendish House, 1948. Right: An advertisement for A. Riches & Co., coal merchants, also from 1948. This was the tiniest shop in the Promenade but, in the early 1950s, had windows packed with an excellent selection of farm animals and Dinky cars. So popular were the toys that, by the 1960s, Riches were listed as coal and coke merchants and toy dealers.

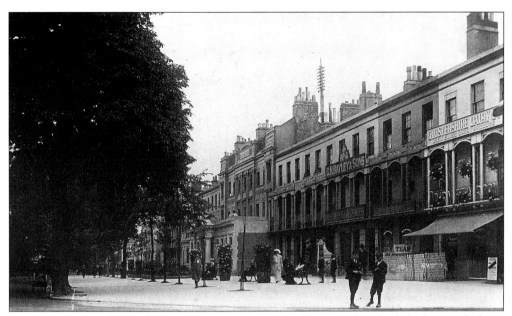

A card, posted in 1908, showing a corner area of the Promenade, which had recently been paved, had young trees planted and ornamental trees displayed in tubs. The General Post Office was housed in the impressive building in the centre of the picture from 1874 until 1987. Shops now occupy this site.

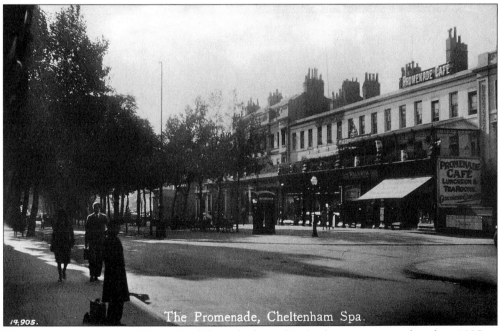

The same corner, now with a red Jubilee telephone kiosk: these were introduced in 1935 to mark King George V's twenty-five years on the throne. The Promenade Cafe, owned by the Gloucestershire Dairy Co., was a popular meeting place in the 1930s and 1940s.

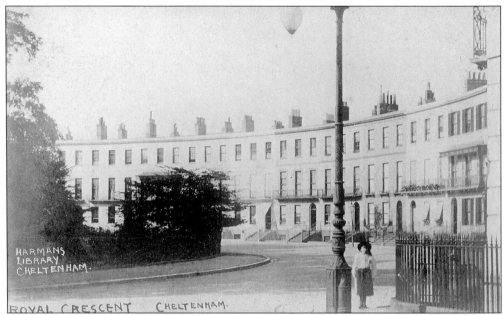

Royal Crescent, behind the Municipal Offices in the Promenade, is considered to be Cheltenham's first major piece of Regency architecture and was built between 1805 and 1825. A bus station was opened in Royal Well Road in 1936. The decision, in 1949, to enlarge the station to include the garden in front of Royal Crescent, was apparently as controversial as the arguments today as to whether the present bus shelters, added in 1955, should be demolished and a garden recreated in the crescent.

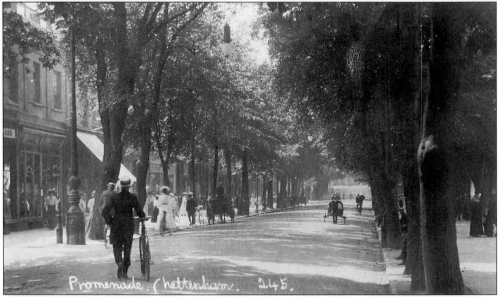

Another postcard produced locally by Norman Bros Ltd. This is the Cheltenham of the guidebooks before the First World War and portrays an affluent society. Elegant ladies leisurely stroll along a tree-lined Promenade, enjoying the fine array of shops. Note the lamp standards, of a type affectionately known as 'tall twins', on either side of the road, with the lamps suspended between the trees.

24

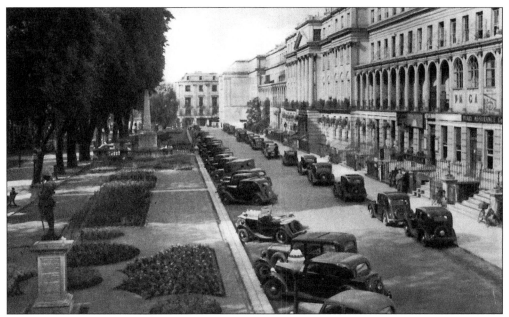

The terrace on the right was built between 1823 and 1825 and was known as the Harward's Buildings after one of the developers, Samuel Harward. The central houses became the Cheltenham Municipal Offices from 1914 onwards. By the 1960s, the part of the terrace seen here, occupied by the YMCA and the Pearl Assurance Co. Ltd, had also been purchased for municipal use. The Long Garden, in front of the building, was originally private and owned by the residents of the terrace.

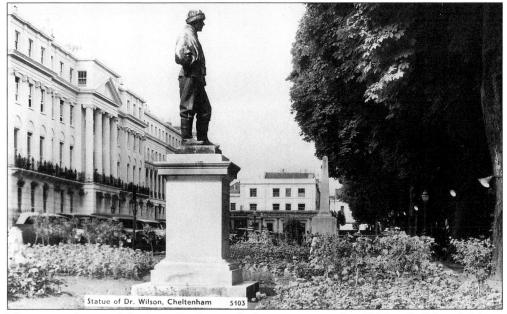

Statue of Dr. Wilson, Cheltenham 5103

This postcard view of the Long Garden, with the statue erected in 1914 to Dr Edward Adrian Wilson, was posted in 1970. Edward Wilson died with Capt. Robert Scott during his ill-fated return from the South Pole in March 1912. The sculptress Lady Kennet, Scott's wife, designed the statue. Local firm R. L. Boulton cast the figure.

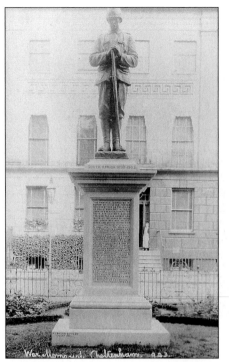

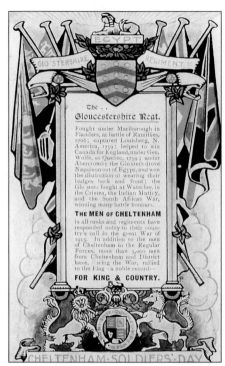

Left: The South Africa War Memorial in the Long Garden was unveiled in 1907 to commemorate the sixty Cheltenham men killed in the Boer War. This photograph, taken shortly after the memorial was erected, shows the Harward Buildings (privately owned at this time) and part of the low, ornate railings, which originally surrounded the Long Garden. Right: A postcard tribute to the Gloucestershire Regiment and all the men from Cheltenham who served in the First World War.

The War Memorial standing in the centre of the Long Garden bears the names of over 1,200 Cheltonians who fell in the First World War. A competition was held to select a design for the memorial. A simple obelisk design by R. L. Boulton & Sons was chosen. The three steps to the memorial are made of local Leckhampton stone, the remainder being made of Portland stone.

Cheltenham's Mayor, Councillor Maureen Stafford, takes the salute in front of the War Memorial in the Promenade, during a rather wet St George's Day parade in April 1989. Andrew Rowley, Giles Cardew, Owen John and Iain Rowley [carrying the banner], 1st Hatherley Scouts, can be seen to the left of the photograph.

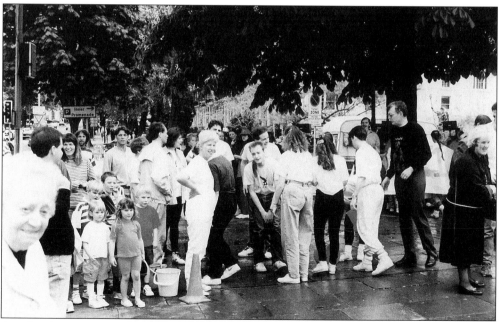

Another busy scene in the Promenade, this time for the fund-raising event, Action Aid. The sponsored teams, including some quite small children, are preparing to run the length of the Long Garden, carrying buckets of water.

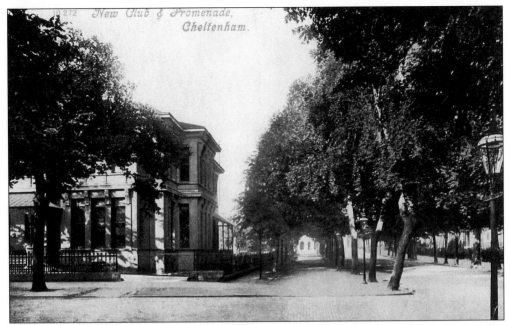

This view from around 1900, shows the New Club, which stood on the corner of the Promenade and Imperial Square. Built in 1874 as an exclusive, gentlemen's club, the New Club was demolished in 1970 and replaced with a modern office block known as The Quadrangle. The Queen's Hotel can be glimpsed through the trees. There is a crossing point in the road in the bottom-centre of the picture, which was there to prevent the bottoms of ladies' long dresses being spoiled.

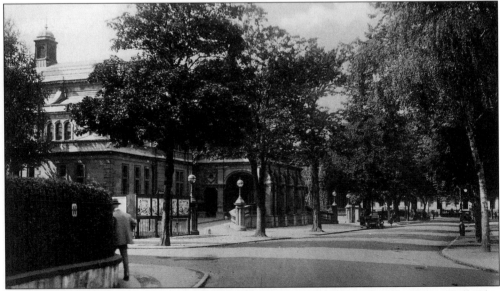

Further along Imperial Square, with the Promenade in the background, is the Town Hall. This was opened in 1906 as a venue for concerts and dances, following the demolition of the Assembly Rooms in the High Street. An effort was made in the early twentieth century to revive interest in the Spa waters. The Central Spa was opened here in the Town Hall and comfortable lounges were provided for visitors taking the waters.

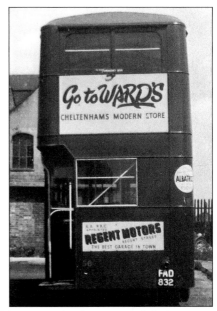

Left: Cheltenham is famous for its festivals. Many well-known artists have started their careers with success here at Cheltenham. The Annual Open Music Competitive Festival was started in 1931. The town's coat of arms, depicting health and learning, is on this programme cover. Right: One of the town's austerity buses, brought into service in 1944 and in use until 1954, pictured at the depot opposite Lansdown Station alongside the Midland Railway line. The advertisements are for Ward's department store in the High Street and Regent Motors, which was situated in Regent Street behind the Promenade – this site later became part of the Regent Arcade development.

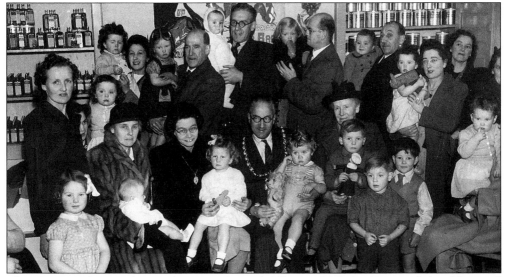

This photograph was taken at the Borough Food Office in Wolseley Terrace, behind Imperial Square, in February 1949. The author is one of the children meeting the Mayor and Mayoress, Councillor H. T. Bush and Mrs Bush. Other children in the picture include: Christine Baker, Susan Ball, and Ann Skinner. No doubt the tins of National dried milk and the bottles of orange juice and cod liver oil will bring back a few memories!

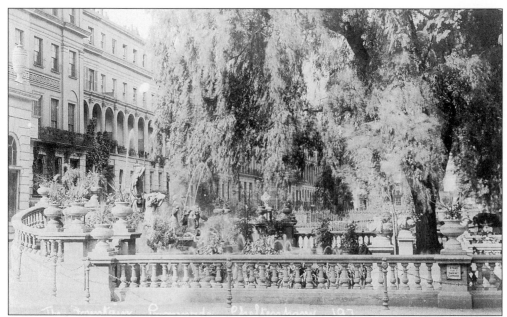

This card, posted in 1903, shows the fountain, with its sculpture of Neptune being drawn by sea horses, in front of the former Imperial Spa in the Promenade. The fountain was designed by Joseph Hall, the Borough Engineer, and constructed in Portland stone by R. L. Boulton & Sons during 1892 and 1893. The railings around the gardens in front of the Harward Buildings can be seen in the background. On the low wall in the front of the picture is a notice, which advises that this is a standing point for one Hackney carriage.

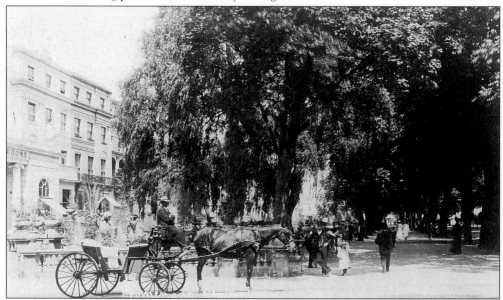

A Hackney carriage awaits, possibly expecting custom from the Cheltenham Model Dairy & High Class Tea Rooms, situated behind the fountain in the former Imperial Spa building. This building was put to a variety of uses before being demolished in 1937. The Regal Cinema opened on this site in 1939 but was demolished in 1985 to make way for the erection of Royscot House.

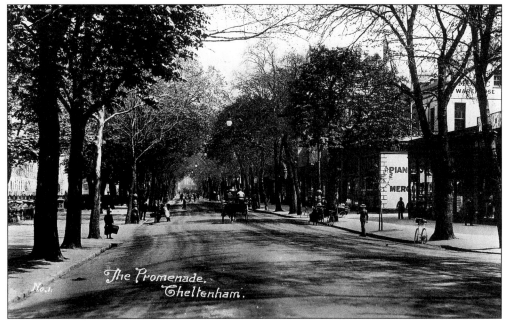

The Promenade, pre First World War. This shows the premises of Dale, Forty & Co., piano merchants, on the corner with Imperial Lane. The lamps, centrally suspended between the trees, are particularly noticeable in this picture.

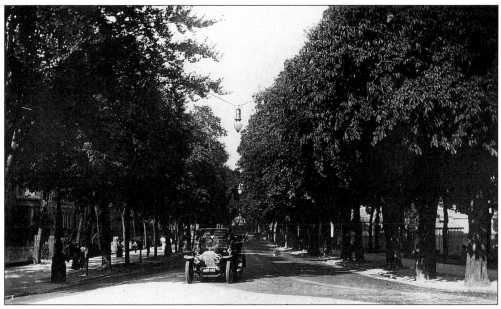

The Promenade from the Queen's Hotel, taken from a card posted on 1 September 1908. A lone motor car is travelling up a deserted Promenade. The railings, seen on the right of the picture, are those surrounding the Winter Gardens. The sender of the card has written 'It is dreadfully rough here blowing the trees in all directions'.

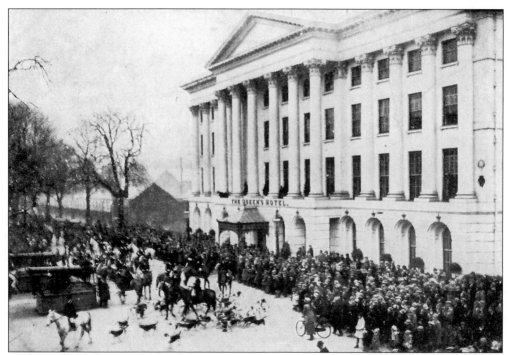

The message on this postcard reads 'We stopped the night here April 13th 1927'. The picture is of the Queen's Hotel, an impressive example of Greek Revival architecture, built during 1837 and 1838, on the site of the Imperial Spa. It was designed by architects Robert & Charles Jearrad. Costing £40,000 and boasting seventy bedrooms, sixteen sitting rooms and thirty rooms for servants (as well as extensive stabling for horses), it was by far the grandest hotel in Cheltenham. The Cotswold Hunt met outside the Queen's Hotel every Boxing Day morning until the mid 1960s.

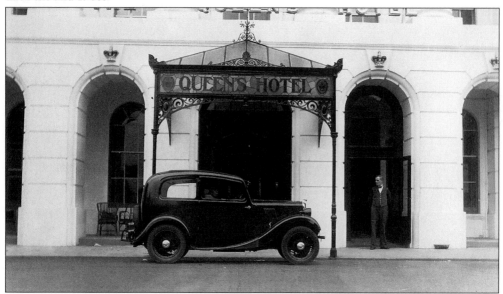

A Standard motor car, parked outside the Queen's Hotel, 1938. This close-up shot shows the fine details of the original canopy over the hotel's main entrance.

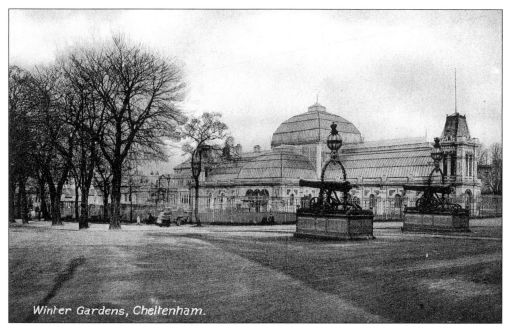

Winter Gardens, Cheltenham.

This postcard was published during the First World War by Jesse J. Gillham of Cheltenham. On the reverse it is marked 'Passed for publication by Press Bureau, 17/11/17'. The two cannons were made in Russia and captured during the battle of Sebastapol in 1856, before being presented to the town of Cheltenham in 1857. They stood outside the Queen's Hotel from 1858, on plinths bearing the names of local soldiers killed in the Crimean War. Regrettably, the cannons were removed for scrap in 1942 as part of the Second World War salvage effort, as were the railings around the Winter Gardens that can be seen in the photograph. The Gardens opened in 1878 for concerts, exhibitions and roller skating.

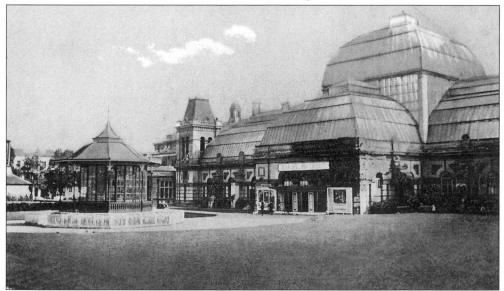

The Winter Gardens, shortly after the bandstand was erected in 1920. The Winter Gardens building was demolished, in 1940, and the bandstand sold, in 1948, to Bognor Regis – where it now stands on the seafront.

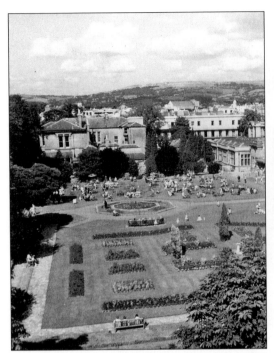
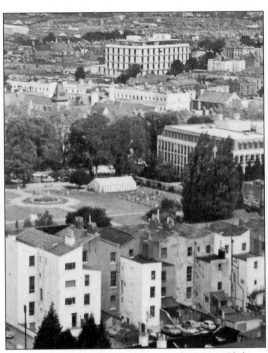

Left: The Imperial Gardens, taken in the 1960s from the Queen's Hotel, showing the New Club and the Town Hall buildings. Right: The Imperial Gardens, along with its familiar beer tent, taken from a postcard sent in 1980. This view is from behind the terrace along Imperial Square towards the Promenade. The Quadrangle building, on the right, stands on the site of the New Club. The former Mercantile & General building, in the background, was built between 1976 and 1977.

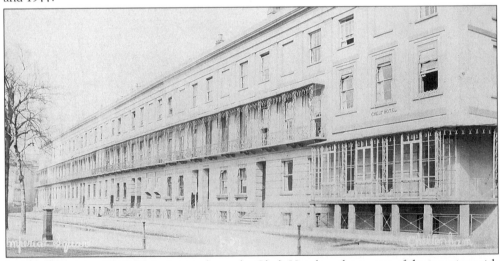

Imperial Square, *c.* 1900. This picture shows the Chelt Hotel on the corner of the junction with what is now Rodney Road. The terraces in Imperial Square were built in the 1830s. Especially notable is the splendid lace-like wrought ironwork of the balconies, featuring the double-heart motif – often referred to as the 'heart and honeysuckle' design. The hexagonal Victorian pillar box, which can be seen on the left, is an example of the design by J. W. Penfold, introduced in 1866.

Three
Around Montpellier and Landsdown

The area around Montpellier was a fashionable place to be in the nineteenth century. Exhibitions and balls were held in the Rotunda, a magnificent, domed room designed by John B. Papworth, which was added to the original Spa building in 1825-1826. Lodging houses were built in tree-lined drives overlooking the Montpellier Gardens, in which events were held for visitors to the town.

Montpellier Walk was originally a tree-lined walkway leading to the Montpellier Spa. In the late 1830s, the trees were removed and a row of shops built, distinguished by the unusual caryatids [known as Cheltenham's 'armless ladies'] between the shop fronts. More shops were built in stages over the next thirty years. The caryatids, representing Athenian virgins, are mostly copies made in stone by W. G. Brown of Tivoli Street, Cheltenham, modelled on terracotta originals by Rossi. Two concrete figures were added in 1970, when the National Westminster Bank was extended.

John Papworth also designed much of the residential development adjoining the new road from Montpellier to Gloucester, known as Lansdown Road.

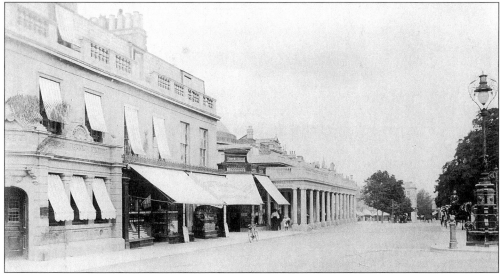

This pre-First World War view of the part of Montpellier Walk now commonly referred to as The Rotunda, shows that the area was already well established as a shopping centre. Shops have been developed along this side of the (former) Montpellier Spa building and, further down Montpellier Walk, the line of shops set back from the road can be seen. The magnificent lamp in the centre of the road was later moved to Tivoli Road, where it still stands today.

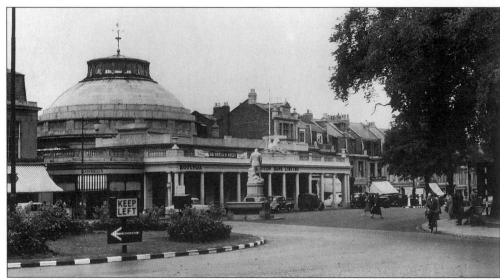

A more modern view, showing the traffic island and Lloyds Bank, now occupying the Rotunda building. The statue erected in memory of King Edward VII, 'The Peacemaker' 1901-1910, and the animals' drinking trough, have replaced the lamp in the centre of the road. The statue of Edward, casually dressed, delicately holding the hand of a pretty, barefoot urchin, is unusual in its informality and was presented to the town by Mr and Mrs Drew of Hatherley Court, who were themselves remembered for their work in rescuing old cab horses and donkeys.

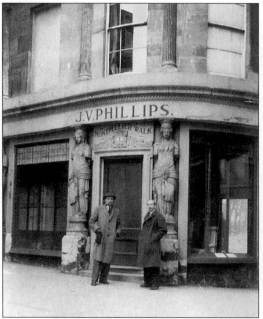
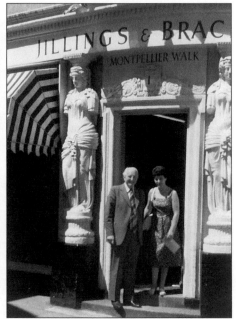

Left: Eric Bracey and Jack Jillings found this shop, in Montpellier Walk, for sale in around 1946. Attracted to the area and having trained in London, before the Second World War, in drapery and men's outfitting, they decided to move to Cheltenham. Jillings & Bracey Ltd, the shop they opened together, is still trading today. Right: Eric Bracey standing in the doorway of the shop with Louise Shipfield (née Phillips), youngest daughter of the shop's previous owner, Mr John Victor Phillips, June 1977.

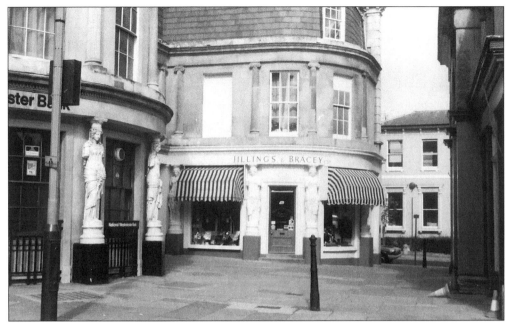

Looking towards Jillings & Bracey's from the road. The National Westminster Bank occupies the bow-fronted building on the left. The caryatids adorning both buildings can be clearly seen. Originally, motor cars were permitted to drive up to the door of Jillings & Bracey's. When cellars were discovered underneath the front of the shop Mr Bracey was concerned for the safety of the public and was instrumental in getting the bollard, which can be seen clearly here, erected to restrict access. A signpost now stands on this spot.

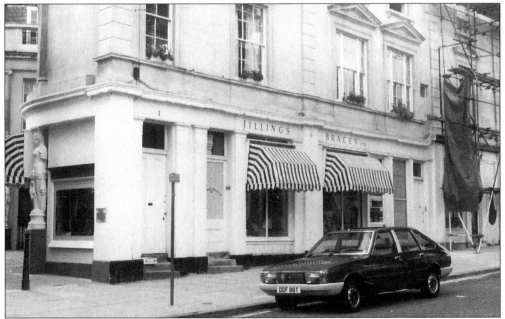

The rear windows of Jillings & Bracey's, Montpellier Street. There is a similar bollard here to restrict traffic to the walkway through to Montpellier Walk. The cellars beneath the pavements here in Montpellier Street were filled in for safety reasons.

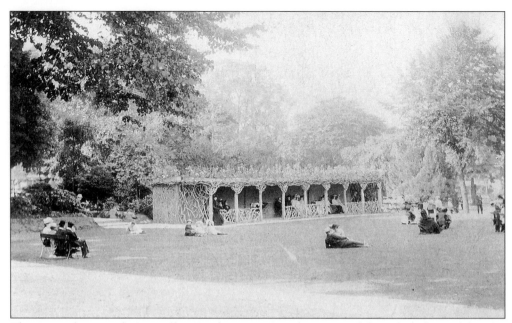

The Council acquired Montpellier Gardens in 1892. This postcard dates from the early 1900s. This rustic-style pavilion is believed to have stood where the refreshment kiosk is today. The well-dressed ladies and gentlemen would appear to be listening to a concert – the bandstand is just out of the picture, to the right.

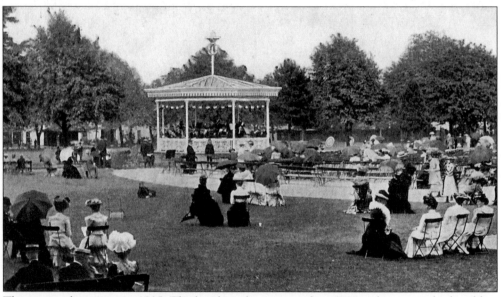

This postcard was sent in 1905. The bandstand was erected in 1864 and is currently the oldest bandstand in the British Isles still in use, having been restored in 1993. The base of the bandstand is deep and roomy and was used to store archery targets: the Cheltenham Archers practised here from 1857 until 1934. The bench seating also served the open-air theatre, situated to the right of the bandstand.

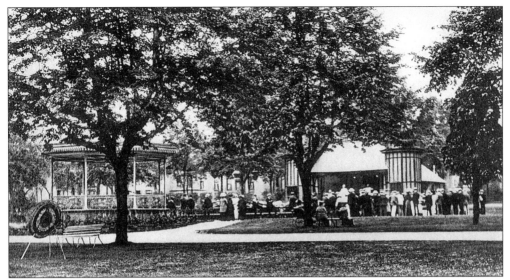

The open-air theatre, or Proscenium, not long after it was built in 1900. The two timbered columns survive as part of the Gym Building today. The houses of Montpellier Terrace can be seen in the background.

Left: Highbury Cubs, including the author's elder son, Jonathan Heasman, gather in Montpellier Gardens for a St. George's Day parade through the town in the early 1970s. The small, wooden hut was used to store and dispense the putting equipment for the small green to the left of the photograph. Right: A band marching through the Gardens, part of the same parade.

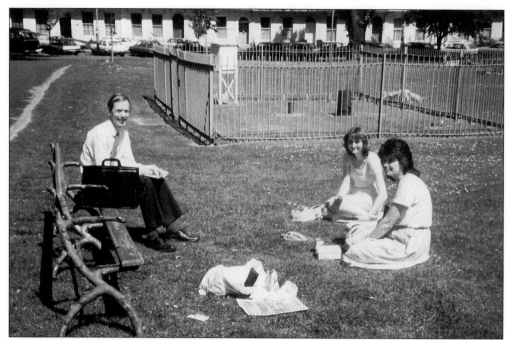

Office workers, Robin Hayward, Jenny Lewis and Sara Austin, enjoy a lunch break in Montpellier Gardens. The bench is one of the few remaining 'rustic' type, recently moved to the area around the tennis courts for safe keeping. Behind the group is the Meteorological Station, where the highest ever recorded temperature for the UK was registered on 3 August 1990. This was a scorching 37.1°C (98.8 °F), which exceeded the previous record, measured in Cambridge, of 36°C in 1911.

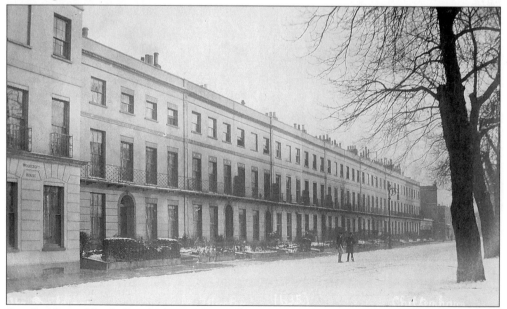

Spa Buildings, North Parade (now Montpellier Spa Road), wintertime, c. 1900. These were much sought-after lodging houses, overlooking Montpellier Gardens. The simple, wrought iron trellis-work of some of the balconies in the terrace dates from before 1820.

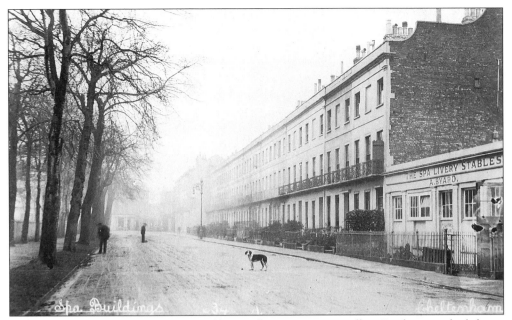

Spa Buildings, looking towards Montpellier Walk, *c.*1900. Montpellier Gardens, on the left, are surrounded by railings, which were supplied by Messrs Letheren & Sons of Cheltenham in 1894. The Spa Livery Stables, at the corner of Trafalgar Street, also operated a popular riding school. This site was later occupied by a garage and car showroom but, more recently, a block of apartments has been built, in the same style as the adjoining terrace.

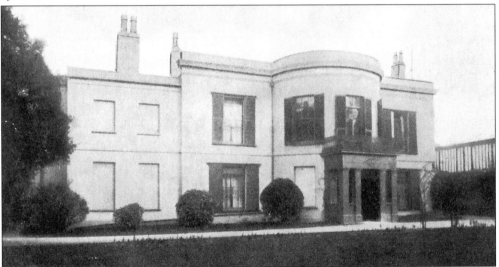

The Hall, Montpellier Parade, *c.* 1900. This building has an interesting history. Originally, it was two houses, The Hall and Boston Lodge, but they were combined. In 1915, Mrs Amy Jane Creese, the wife of a shopkeeper in Montpellier Walk, purchased Phoenix Lodge, the house next door (today known as Star Lodge). Mrs Creese renamed this house Atherstone Lawn, after her former home in Portland Street. In 1935, Mrs Creese sold Atherstone Lawn and purchased The Hall, changing its name also to Atherstone Lawn. The new owners of the former Atherstone Lawn reverted to the original name, Phoenix Lodge. The Hall has been known as Atherstone Lawn since 1935 and, since 1970, has been home to The New Club.

Mr Eric Bracey took this picture of the Eagle Star Building, through the trees in Montpellier Gardens, shortly after it was erected. Eagle Star House, as it was originally called, was officially opened on 18 October 1968. In 1994, it was renamed Eagle Star Centre.

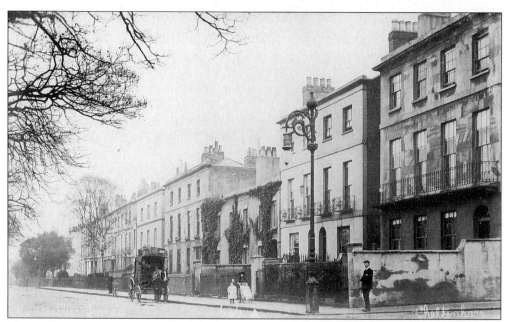

Montpellier Terrace, formerly South Parade, looking towards Bath Road from the junction with Suffolk Parade. Note the contrasting ironwork designs in the first two blocks of housing. Further down, at no. 91 (previously no. 6), Dr Edward Wilson was born, in 1872.

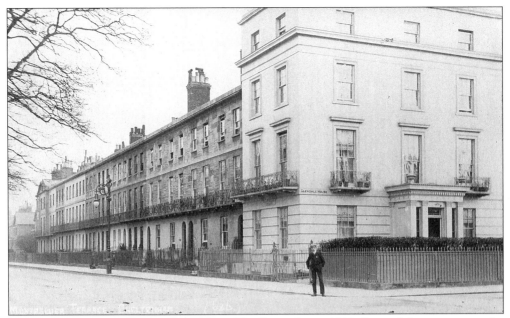

Montpellier Terrace, looking down from The Rotunda, *c.* 1900. Part of the terrace can be traced back to before 1820. Glendale House was later used by Coles Surveyors for many years.

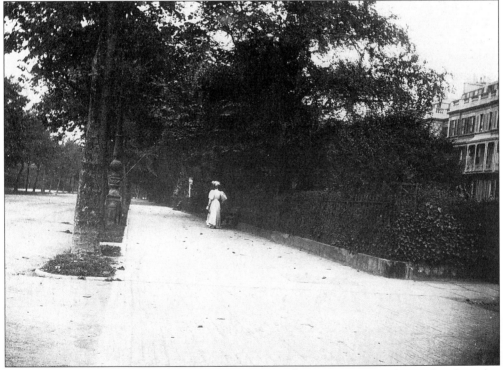

Lansdown Road at the junction with Lansdown Walk, *c.* 1900. Note the enclosed private gardens belonging to the houses in the terrace known as Lansdown Place. The base of a Tall Twin lamp standard can also be seen. This is decorated with details depicting the town's coat of arms, pigeons and acanthus leaves.

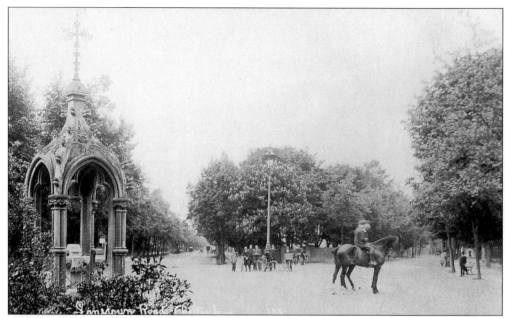

Lansdown Road at the junction with Queen's Road, early 1900s. The drinking fountain was donated to the town by the Misses Whish in 1891. In 1929, when the area was developed to cope with the increased traffic, the fountain was moved to the Keynsham Road end of Sandford Park.

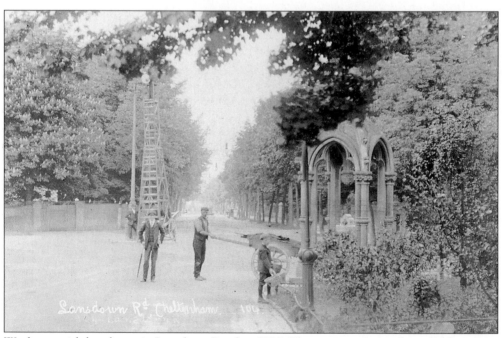

Workmen with hand carts in Lansdown Road, c. 1900. They are using an early scaffold tower to repair the lamp standard. More lamps can be seen, suspended between the trees, stretching into the distance down Queen's Road.

Four
Pittville and St Paul's

Pittville and St Paul's are two very different parts of Cheltenham and yet are linked in a number of ways. Both areas were being developed at around the same time to provide housing. However, Pittville was more fashionable in the 1820s and its tree-lined terraces and classically designed villas attracted the best of society and visitors to the town, whereas housing in the St Paul's area spread from the densely populated streets leading from the High Street satisfying the needs of the less well-off working classes. Pittville has remained a much sought-after place to live; St Paul's underwent considerable slum clearance and redevelopment from 1925 onwards. Today St Paul's is a much improved area and now boasts a strong community spirit.

Pittville was owned and financed by Joseph Pitt, a wealthy lawyer and banker. He laid out the gardens and estates and employed a local architect, John Forbes, to build the Pump Room. Joseph Pitt also gave the land for St Paul's church to be built, insisting it serve the poor of Cheltenham. Again, John Forbes was the architect commissioned for the work.

Francis Close came to Cheltenham in 1824 as curate of Holy Trinity Church. He also worked to promote education for all classes. The main building of St Paul's College was renamed Francis Close Hall in his memory in 1979.

The wedding of Brian Hyde and Brenda Uden at Holy Trinity Church, Portland Street, on 1 September 1962. Brian and Brenda met in Dover, whilst Brian was doing his national service with the Glosters, with whom he served as a drummer. They settled in Cheltenham and Brian later started his own business, Brian Hyde Heating & Plumbing Engineers. The church has now been extended where the group is standing. Some of the buildings seen behind the group have been demolished and some rebuilding has taken place.

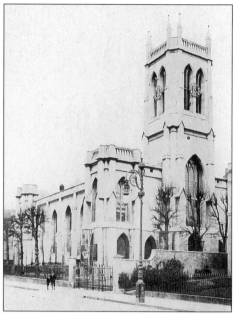

Left: The bridesmaids at Brian and Brenda Hyde's wedding were, on the left, Diane Francis (née Hyde), the groom's sister, and Diane Crofts (née Uden), sister of the bride. Unfortunately, the memorial slabs on which the girls are standing, are now almost unreadable. The houses seen in the photograph, opposite the entrance to Holy Trinity church in Portland Street, were demolished to make way for the car park. Right: Built between 1820 and 1823, Holy Trinity was the second Anglican church in Cheltenham. Originally, almost all the pews were privately owned, visitors paying one shilling to attend a service. This early twentieth-century postcard picture shows the church with its pinnacles, which were later removed when they became unsafe, and also its railings and gates, which were removed for salvage in the 1940s. Today, a wall has replaced the railings and similar gates have been erected to protect this beautiful building.

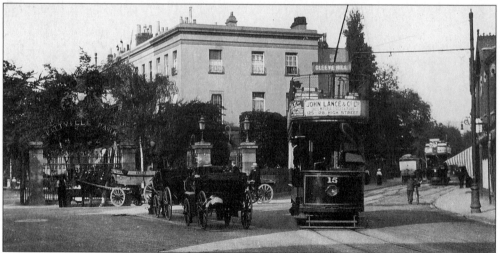

Pittville Gates, c. 1905. The iron arch displays the words 'Pittville Park'. It was made locally by Letherens and erected by the Town Council in 1897. The number 15 tram, seen here on the Cleeve Hill route, was one of the later trams, with safety railings on the upper deck.

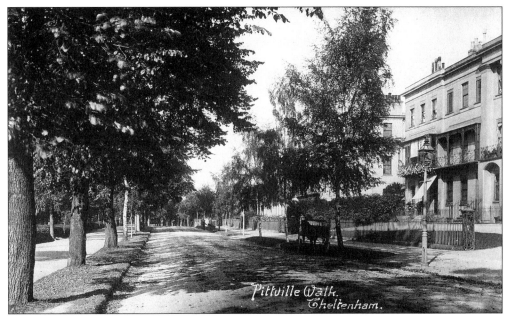

This locally produced postcard has been overprinted 'F. Norman, Waverley Stationery Works, Cheltenham'. The attractive, tree-lined Pittville Walk is now part of Pittville Lawn. Today, the houses on the right have lost much of the attractive ironwork from their verandas and the railings bordering the pavement have also gone, The long garden to the park on the left, however, remains unspoilt and the road retains its earlier charm.

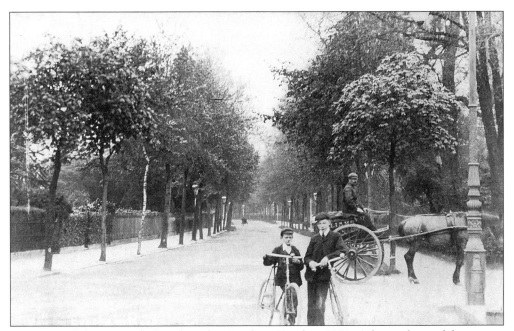

Two young lads pose with their bicycles, Evesham Road, *c.* 1900. A horse-drawn delivery cart has stopped to look at the photographer. Note the decorated base of a 'dragon and onion' lamp standard in the foreground.

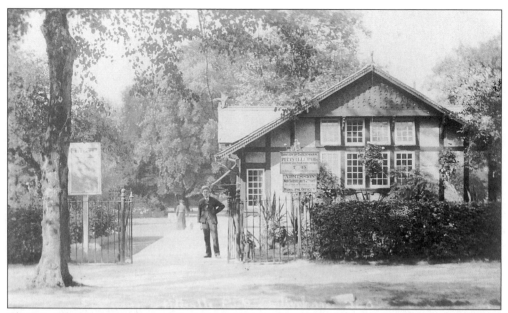

The Pittville Gardens were acquired by the Council in 1890 and an entrance fee was charged until 1954. When this photograph was taken, around 1905, admission was 2d, although one could apply to the Municipal Offices for membership. The timber-framed building at the entrance to the park was built in 1903. Today, this is the popular refreshment kiosk.

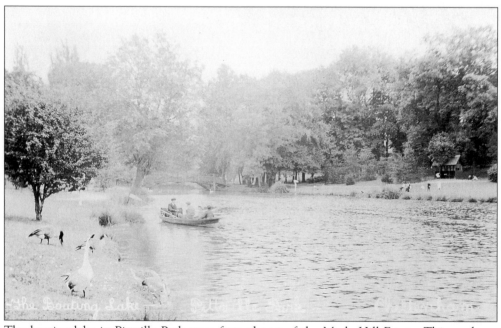

The boating lake in Pittville Park once formed part of the Marle Hill Estate. This card was postmarked 11.45 am, 6 June 1907, and was to be delivered to Miss Biggs, Holmains, Wellington Square. It bears the message 'Dear J. am off this evening will be down at 6 pm'. Local postal deliveries were obviously a very prompt and reliable service!

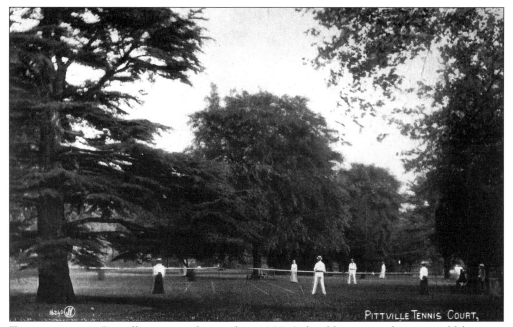

Tennis courts at Pittville on a card posted in 1908. I should imagine that it would be most uncomfortable playing tennis on a hot summer's day dressed like this!

The author's niece, Cindy Louise Collins (née Smithers), reliving her childhood yesterdays in Pittville Park on a visit from Australia in 1980. In the background are the Pump Rooms and bandstand and, to the left of the picture, one of the aviaries.

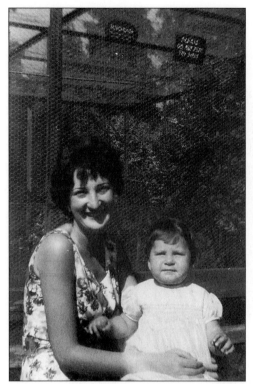

Left: The author's sister, Geraldine, with her daughter, Cindy, sitting in front of one of the aviaries in Pittville Park, 1961. The small birds and animals and brightly-coloured peacocks have been favourites with children over the years. These aviaries were vandalised recently but, happily, were replaced almost overnight. Right: Cindy having fun on the big slide in the early 1960s.

A contrasting scene of children playing in Pittville Park in the 1990s. The playground has been refurbished. The little boy on the train, with the painted face, is Christopher Rowley.

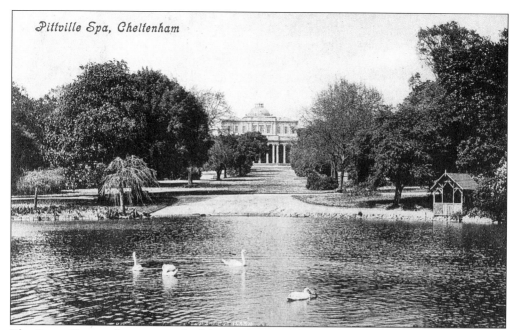

Pittville Spa, Cheltenham

The Pump Rooms, from across the lake, on a postcard sent in 1906. The Pump Rooms were designed by a local architect, John Forbes, and built between 1825 and 1830. The building is based on an engraving of the Temple of Ilissus in Athens. The local Spa waters were dispensed on the ground floor and on the second floor were situated a library, reading room and billiard room. The Pump Rooms later became popular as a venue for exhibitions, flower shows, rallies and banquets.

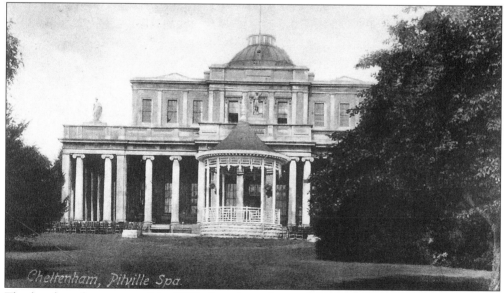

Cheltenham, Pitville Spa

The bandstand was erected in 1900, directly in front of the Pump Rooms. This postcard is another example of the efficiency of the postal service in the early twentieth century. It is postmarked at: 10.45 am, 9 October, 1909, and is addressed to Miss Honeysett, Handel House, St George's Place. The message reads 'Dear Mabs, Will you come up as early as possible this evening, Love from Ralph'.

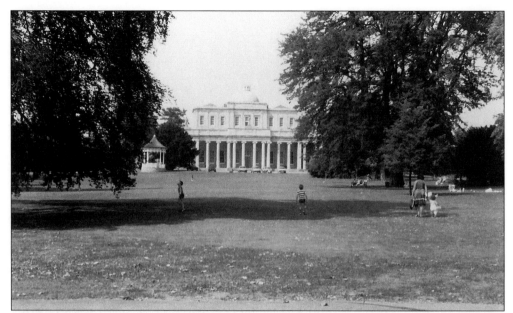

A more modern view of the Pump Rooms, taken in 1985 with cars parked in front. Notice the difference in the position of the bandstand, which is now situated to one side of the Pump Rooms. It was moved there in 1901, shortly after its construction.

After the Second World War, the Pump Rooms underwent considerable restoration and refurbishment. The official reopening was by the Duke of Wellington on 4 July 1960. This photograph was taken at a Drapers' Ball, in the early 1960s. In the picture, from left to right, are: Jack West, Cynthia Bracey, Hugh Crawford, Joane West, Eric Bracey and Margaret Crawford.

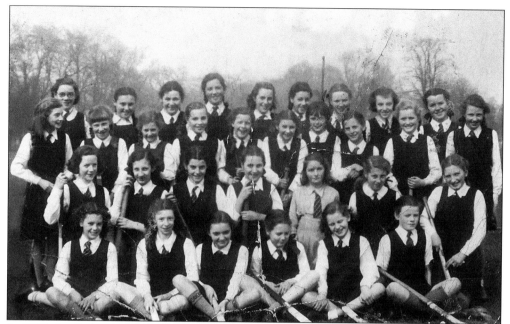

In 1905, the Richard Pate Foundation established a girls' grammar school at Livorno Lodge, St Margaret's Road. The school moved to Albert Road in 1939. In 1986, it became Pittville School. This photograph of Form 1R, taken in 1948, was loaned by Mrs Rosaleen Cecil (née Nelson), who is in the bottom right of the picture. Also in the group are April Bullock, Carol Joseph, Janice Pinchin and Molly Moth. The photograph of the girls with hockey sticks was taken to send to their form teacher, who was in hospital.

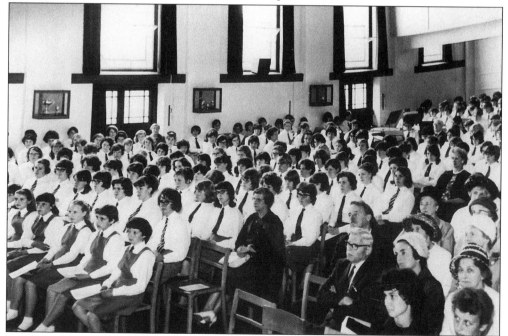

Pate's Grammar School pupils, parents and staff, the school hall, early 1960s. Members of staff include Miss Archer, Miss Edwards, Mr Wilson and Mrs Wilson.

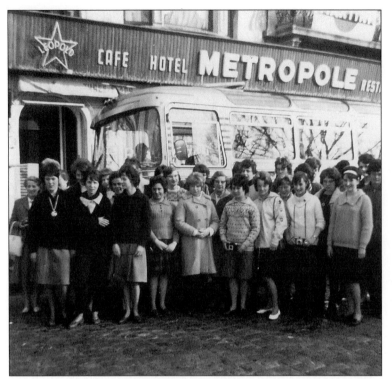

This party of Pate's Grammar School girls enjoyed a ten-day trip, overland to Switzerland, at Easter 1963. The group was accompanied by teachers: Miss Archer, Miss Edwards, Mrs Jeacock and Miss Reid. The all-inclusive cost of the trip, per pupil, was £29 6s 0d. The group is pictured here outside the Hotel Metropole, Blankenberge, on the return journey.

Pate's Grammar School outing to Compton Wynates, 1961. Notice that all the girls are carrying the grey felt hats, which were an obligatory part of the uniform. From left to right, back row: Heather Parry, Diane Jessop, Carol Lewis, Marilyn Pink, -?-. Front row: Mary Hewitt, Erika Davies, the author, Janet Martin and Celia Finch.

Form 5S on the last day of the Summer term 1963, sitting on the steps at the front of the school in Albert Road. From left to right, front to back: Diane Jessop, Mary Hewitt, Heather Parry, Sally McCleave, Carol Lewis, Mrs Jeacock, Susan Blair, Patricia Lacey, Sheila Graham, Carole Fruin, Mariane Warmington, Rosemary Derrick, Jacqueline Else, Janet Robson, Sandra Smith, Margaret Karn, Pamela Banting, Marilyn Pink, Veronica Mayo, Janet Douglas, Margaret Abbott, Jennifer Rose, Susan Price, Diane Gutteridge, Susan Chinery, Janet Martin.

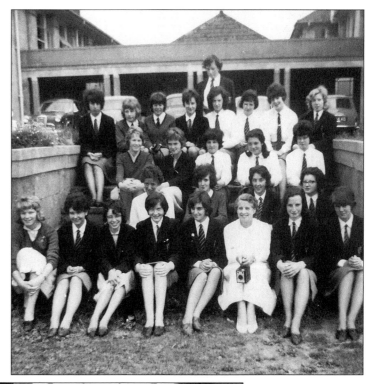

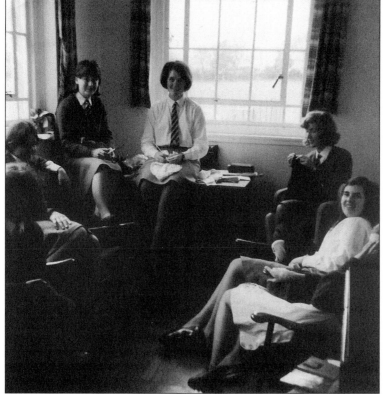

Knitting seems to be a favourite pastime of this group in the Prefects' Room, 1965. The girls are, from left to right: Carole Fruin, Eileen Mason, Sheila Godwin, Lorna Murray, Felicity Lott, Francis Rowe and Moya Job.

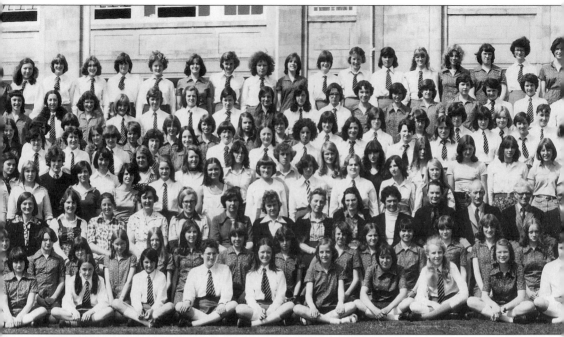

This extract froma Pate's Grammar School group photograph, taken in front of the school building in Albert Road, in May 1977, was loaned by Alison Pascoe (née Brett), seen here in the back row, fifth from right. Other girls pictured include: Amanda Bailey, Diane Farr (née Outram), Janet Hawkes, Vivian Mills, Pia Muir and Miranda Soar. The headmistress, Miss Mary M. Moon, was absent at the time this was taken and her photograph was superimposed by

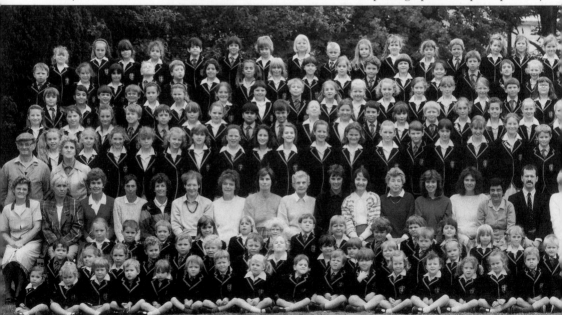

Berkhamstead School, in Pittville Circus Road, opened more than fifty years ago. The headmaster (now retired), Mr Marsh, is pictured in the centre of this photograph of pupils and

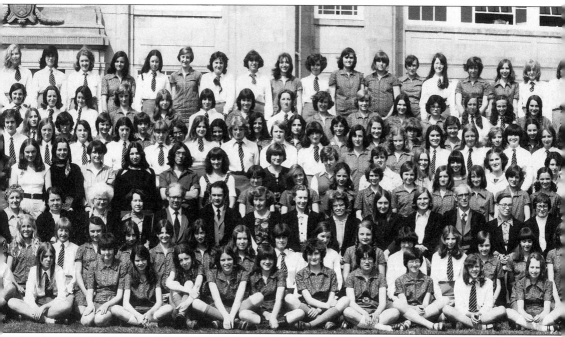

the photographer between teachers Mrs Huddlestone and Mr Furber. Mr Eric J. Phillips, seated in the same row, fourth from right, was then the Head of Maths. Following his retirement from teaching, after more than twenty years at Pate's, Eric Phillips served as Mayor of Cheltenham, 1989-1990.

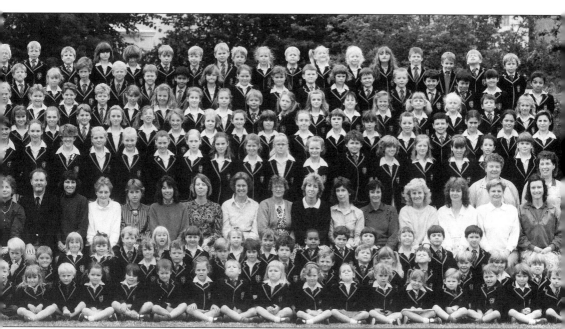

staff, which was taken in 1990. Pupils include Sarah Edmondson, Lavinia Gough, Victoria Inch, Gemma Leithart, Holly McDonald, Sally Radford, Helen Rowley, Nadine Taylor and Emily Wilkins.

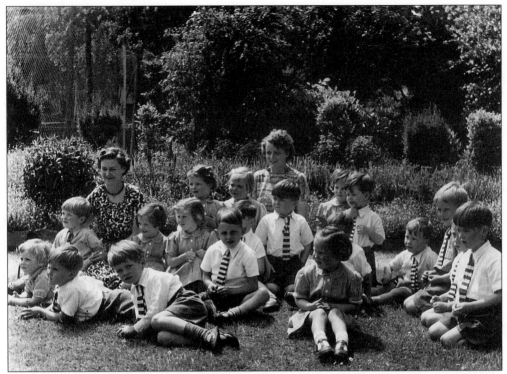

Sports Day at Berkhampstead School, 1951. A group of four and five year olds, including the author, are watching the activities with interest. Two teachers, Miss Curr and Miss Dixon, look on proudly.

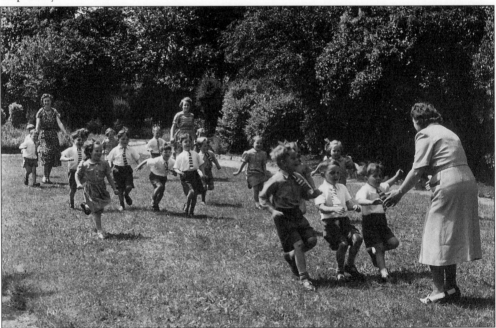

The same group of children get their chance to take part. Acknowledging the winner of the race is the school's principal and founder, Mrs Robin Andrews.

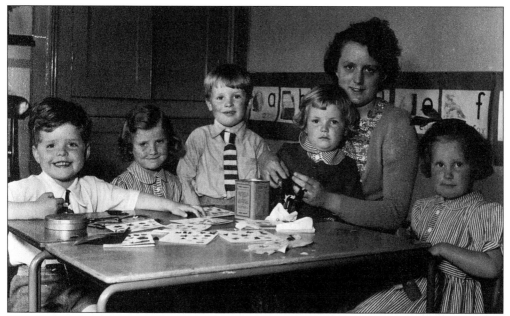

Miss Curr and pupils, including the author (far right), 1951.

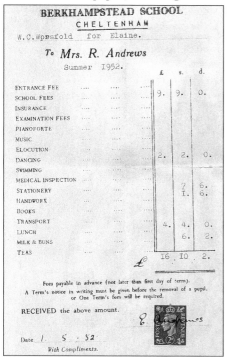

BERKHAMPSTEAD SCHOOL
CHELTENHAM

W.C.Wossfold for Elaine.

To *Mrs. R. Andrews*

Summer 1952.

			£	s.	d.
ENTRANCE FEE			
SCHOOL FEES	9.	9.	0.
INSURANCE			
EXAMINATION FEES			
PIANOFORTE			
MUSIC			
ELOCUTION			
DANCING	2.	2.	0.
SWIMMING			
MEDICAL INSPECTION			
STATIONERY		7. I.	6. 6.
HANDWORK			
BOOKS			
TRANSPORT	4.	4.	0.
LUNCH		6.	2.
MILK & BUNS			
TEAS			
		£	16.	10.	2.

Fees payable in advance (not later than first day of term).
A Term's notice in writing must be given before the removal of a pupil,
or One Term's fees will be required.

RECEIVED the above amount.

Date 1. 5. 52

With Compliments.

Berkhampstead Preparatory School

GENERAL RULES.

1.—All Children are forbidden :—

(a) To bring any money to School except legitimate 'bus fares.

(b) To use or have in their possession slings, catapults, pea-shooters, or water-pistols.

(c) To ride bicycles in any playground, or to ride on the step of any bicycle.

(d) To bring toys of any description to School (this does not apply to members of the Kindergarten).

(e) To walk at any time or anywhere more than three abreast. **They must always take the outside when they meet or pass other people on the footpath.**

Left: Invoice for the Summer term 1952. The author can remember, as if it were only yesterday, the wonderful smell of the currant buns being delivered mid-morning, for the children to have with their milk.

Right: The school rules from the 1950s are rather amusing to read. Children must not have catapults or pea-shooters and when walking must always walk on the outside when passing other pedestrians!

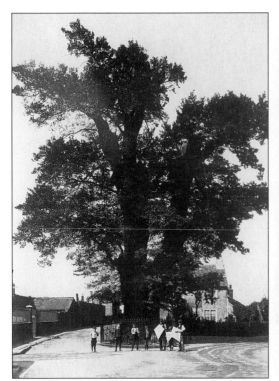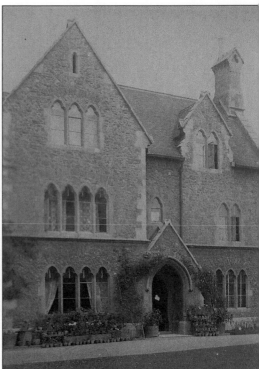

Left: This Elm, in Swindon Road, stood eighty feet high and was known as Maud's Elm, after Maud Bowen: she was a young woman who is said to have been buried at this spot with a stake through her body, which grew into a tree. This photograph was taken shortly before the tree was struck by lightning and subsequently cut down in 1907. Right: The entrance to St Paul's College, Swindon Road. The college, founded in 1847, was one of the country's earliest Anglican teacher-training colleges. The main college buildings were built in 1849.

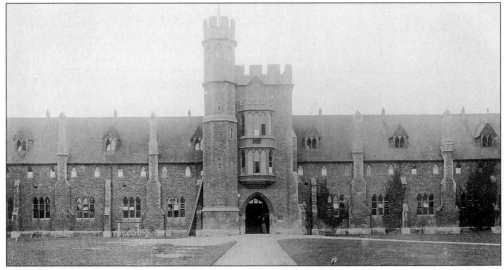

St Paul's College. This postcard is another one produced locally by printers Norman Bros Ltd, prior to the First World War. The college building was designed in the Tudor gothic style, as the battlements, turrets, oriel windows and pointed archway over the entrance clearly show.

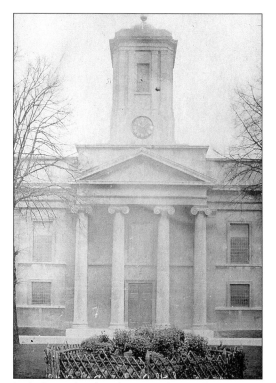
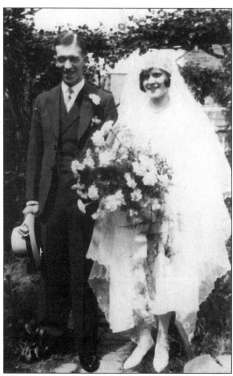

Left: St Paul's church, St Paul's Road, was built between 1829 and 1831 in, what was then, the poorest part of Cheltenham. In direct contrast to Holy Trinity church, all sittings in St Paul's were free. Right: The wedding of Ted Heasman and Lilian Jakeway, daughter of Frank and Lizzie Jakeway (née Woollen), took place at St Paul's church, 7 June 1930. The happy couple are pictured here after the ceremony, at the bride's parents' home, Roath Cottage, no. 94, Swindon Road, later demolished.

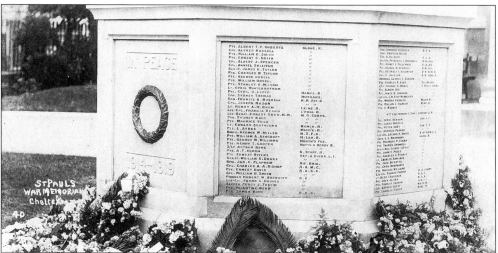

This First World War Memorial stands in front of St Paul's church to honour the local men who were killed in the war. The photograph of the church (above) was taken before this memorial was erected and shows the small garden with a wooden fence that once occupied the position where the memorial is now.

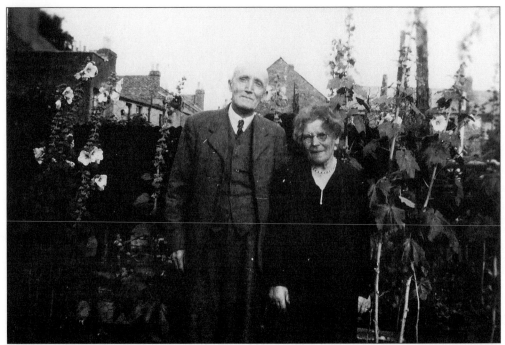

Frank and Lizzie Jakeway, standing in the garden of Elm Cottage, no. 100 Swindon Road, 1940s. This building was later demolished.

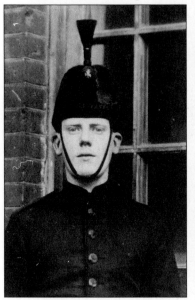 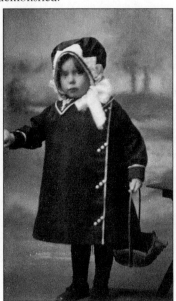 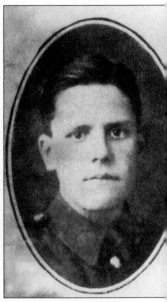

Above: Private Edwin Jakeway, son of Frank and Lizzie, was wounded 14 September 1914, at the Battle of the Aisne. He died from his injuries eight years later.

Above centre: Ivy Jakeway, aged three years old, dressed in a new outfit ready to visit her brother, Edwin, in Paignton hospital, 1914.

Above right: Private Frank Jakeway, 7th Gloucester Regiment, was killed 11 August 1915, at the Dardanelles. Frank was the second son of Frank and Lizzie Jakeway, who were living at no. 1, Devonshire Street in 1915.

Five

Bath Road and Naunton Park

The Bath Road runs from the upper High Street to the Norwood Arms, where the road continues to Leckhampton, as Leckhampton Road, and branches out right to Gloucester, as the Shurdington Road. Bath Road itself has been defined as 'lower' or 'upper' over the years. The area between the High Street and the junction with Thirlestaine Road has seen many changes, including a considerable amount of demolition and rebuilding, whereas the part of the Bath Road between what is now The Midland Bank and the Norwood Arms, appears to have changed very little. The area remains popular for shopping and, although many shops have obviously changed hands over the years, many are family owned and long established in the area.

I spent much of my childhood in the Bath Road. My parents owned The Corner Shop and my father ran a wholesale stationery business in the area. I attended Naunton Park School until the age of eleven and have lots of happy memories. Naunton Park 'rec' was important to us as children. We played hide-and-seek around the burial mound and we dared each other to go even faster on the antiquated strides in the playground, the poles of which were also used for maypole dancing. There was a close-knit friendly community here when I grew up, which I believe still exists today.

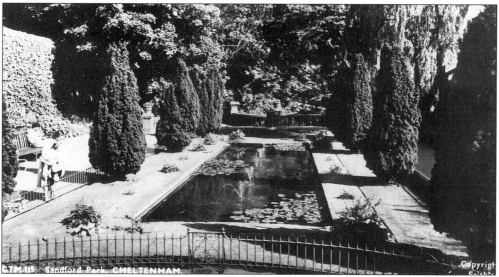

Sandford Park stretches from Bath Road and the Upper High Street to Keynsham Road. It was acquired by the Council in 1927. This photograph, taken in the 1950s, shows the lily pond at the entrance to Bath Road. Sadly, there are no goldfish in the pond nowadays.

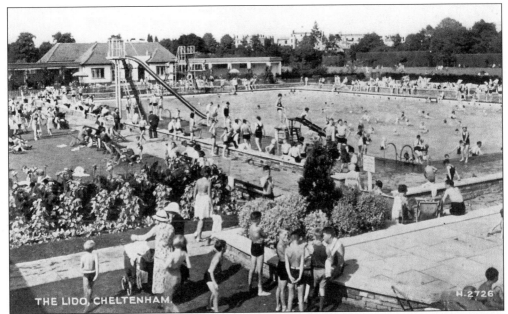

THE LIDO, CHELTENHAM. H.2726

The Lido, in Sandford Park, was built in the 1930s for Cheltenham Borough Council. It is a popular amenity and these 1950s scenes are typical of any hot summer's day. At this time, the Lido provided a choice of pools, areas for sunbathing or playing ball and a cafe. The Lido is currently run by a charitable trust, which has introduced new activities such as volleyball, basketball and even open-air theatre. Further modernization is planned to take the Lido into the twenty-first century.

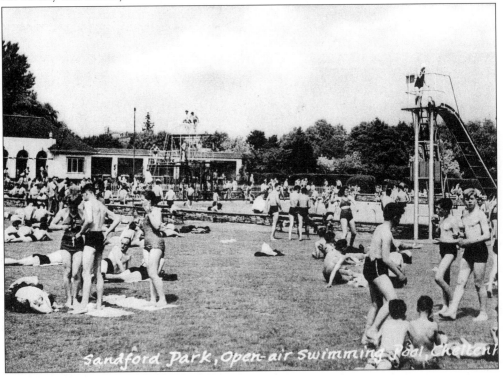

Sandford Park, Open-air Swimming Pool, Chelten

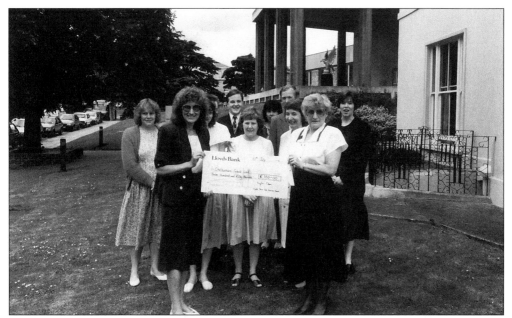

Eagle Star staff have participated in many fund-raising events over the years. In July 1991, this group handed over a cheque for £350, with a further £200 to be given by the company under its Matching Gifts scheme, to the local Cobalt Unit Magic Bullet Appeal co-ordinator, Jeanne Ramsbottom. Pictured here outside the Eagle Star Centre in Bath Road are, from left to right: Nicky Knight, the author, Jenny Lewis, Neil Stevens, Martyn Smith, Irene Hall, Ruth Bowell, Robin Hayward, Felicity Leighton, Jeanne Ramsbottom and Susie Bishop. The building on the right is the former Montpellier Hotel, restored by Eagle Star and renamed Eagle Lodge.

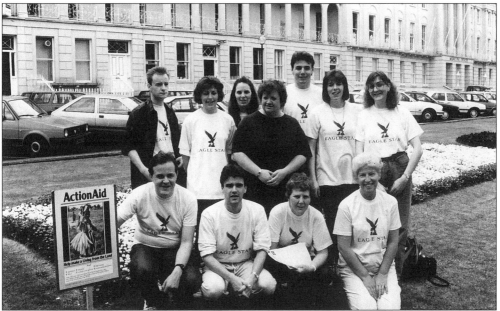

Action Aid fund-raising event, the Promenade, 1993. This is the Eagle Star team, from left to right, front row: Martyn Smith, Vince Strachan, Irene Hall, Trish Brett. Back row: Neil Stevens, Liz Connole, Angela Caster, Karen Hoyles, Nick Ingram, Susie Bishop, Jenny Lewis.

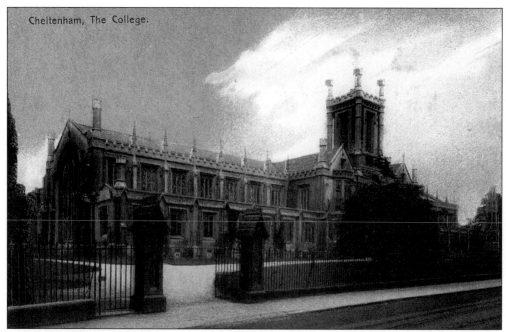

Cheltenham, The College.

The main Cheltenham College building in the Bath Road. This picture was taken soon after the Old Cheltonians South Africa War Memorial (on the far right) was erected in 1903. The building itself dates back to the 1840s. The pinnacles on the tower were removed after the Second World War, as one had fallen and the others had been declared unsafe. The railings were also removed, like many others in the town, for salvage during the war.

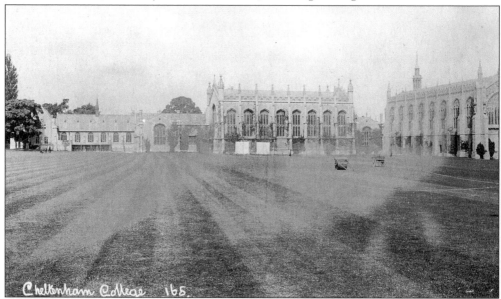

Cheltenham College buildings, a Norman Bros postcard, early 1900s. The gymnasium, built in 1865, is on the left of the photograph. The old chapel (in the centre) was, at one time, used to house the museum and the new chapel, built in 1891, is pictured on the right. Cricket Week was introduced in 1878 and given festival status in 1906. The Cheltenham Cricket Festival is held each summer on the College grounds.

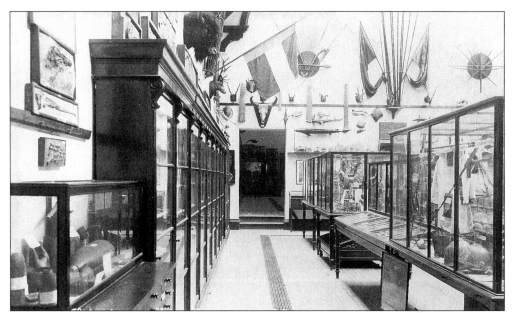

In 1870, one of the original rackets courts was converted into a museum 'to interest the pupils in the study of science and natural history'. Dr Edward Wilson, who attended the College in the 1880s, was indeed fascinated by animals and birds and went on to become a quite remarkable naturalist. Whilst at the College, he won the geology prize twice and, in his final year, the prize for the best collection of eggs, butterflies and moths.

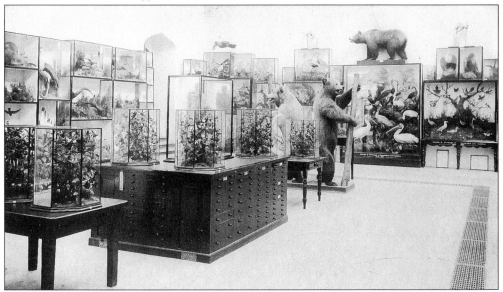

The College amassed an enormous amount of material in the museum, as is evident from these two photographs of around 1900. The articles came mainly from former pupils and included all manner of stuffed animals – there was clearly more than one brown bear! Unfortunately, when the College was evacuated in 1939, the entire contents of the museum were boxed up and stored. Although some articles were later returned to display, the museum was never formally reconstructed. The majority of the original contents were sold in the 1970s, a large proportion going to the City of Liverpool, for its museum.

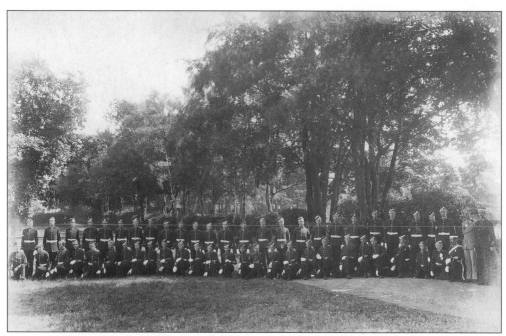

Cheltenham College Cadet Force, c. 1897. This photograph was probably taken as part of the celebrations for Queen Victoria's Diamond Jubilee, in Sandford Park. Note the distinctive flat caps the boys are wearing.

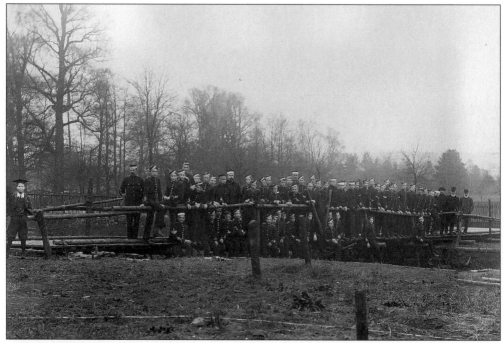

Bridge building has always been a popular exercise with the Cadet Force. Major W. Bell Haworth, a teacher at the College for almost forty years, is with this group of cadets. This photograph is thought to have been taken in 1896. A boy on the left is wearing a mortar-board: these were compulsory until 1956.

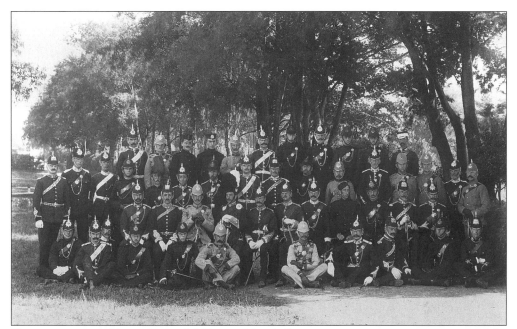

This group is probably made up of old boys of the College, representing various regiments of the British Army – hence the variety of uniforms – as part of the same Jubilee celebrations as the photograph on the left.

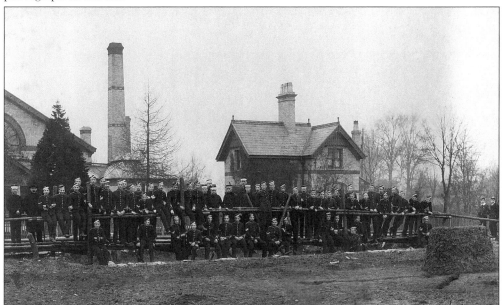

The same group of cadets with Major Bell Haworth. This view clearly shows the location of the bridge-building exercise. The building to the left is the old College swimming baths in College Baths Road, built around 1880, whilst on the right is the poolkeeper's cottage. Both buildings are still standing, albeit in a sadly dilapidated condition. The land to the front and rear of the buildings is now occupied by the fire station. In front of the baths can be seen a Wellingtonia tree which has now grown to a magnificent height. The River Chelt still flows to the right of the poolkeeper's cottage and, presumably, provided the ideal training ground for these cadets.

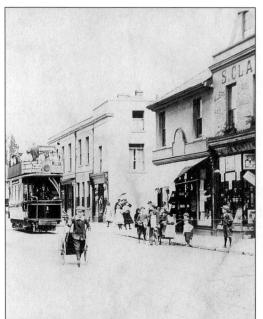

Left: Bath Road, *c.* 1905. The first trams were delivered to Cheltenham in 1901 and the service was extended to cover Leckhampton in 1903. Here, number 1 tram is seen travelling up the Bath Road towards Leckhampton. S. Clark's grocery store is on the right.

Right: A popular figure in the Bath Road for many years was Ivy Brown (née Jakeway). Born in 1910, this picture was taken before the Second World War.

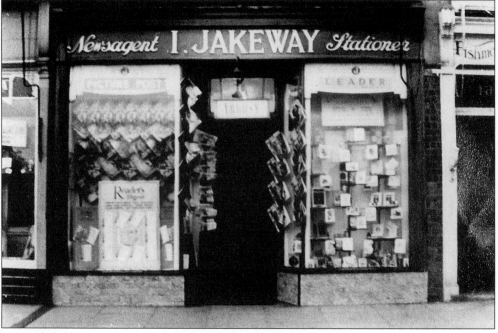

Ivy traded from no. 196, Bath Road and in 1945 also ran a small lending library. This photograph is from the 1950s. The shop remained in the Jakeway family until 1997.

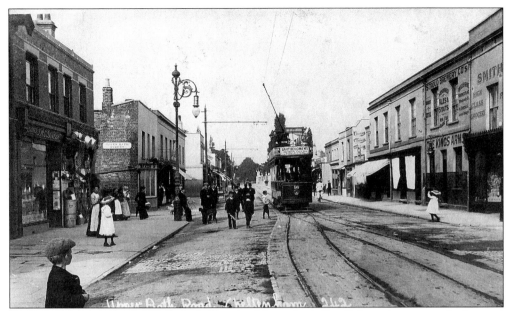

This part of the Bath Road is described as the 'Upper Bath Road' from this postcard of around 1910. A later tram, number 16 – one of eight trams delivered in 1905 – can be seen here. The shop on the left, now Leat & Son, was then J. M. Cox's. A hardware store stands on the corner of Upper Bath Street. The bakery on the opposite corner looks very much as it does today. The Kings Arms public house on the right has gone.

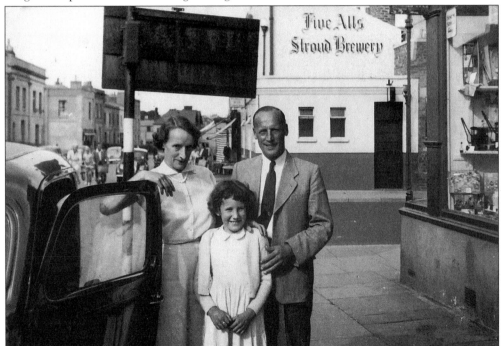

The Corner Shop, at the junction with Francis Street, looking down Bath Road in the 1950s. The author is standing outside the store with her uncle, Harold Worsfold, and aunt, Lilian Lightfoot (formerly Young). The Five Alls public house can be seen in the background.

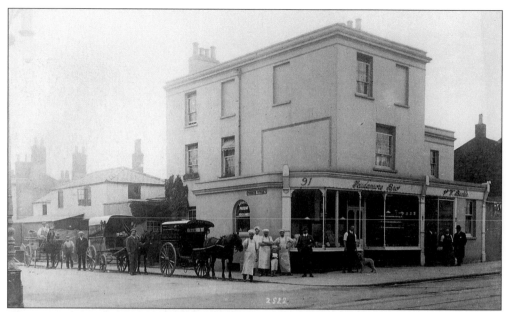

The corner of Bath Road and Francis Street, c. 1900. Scudamore Bros appear to be selling animal foodstuffs. Outside are delivery carts belonging to Buckle & Co., who occupied the shop next to Scudamore's. The base of a dragon and onion lamp can be seen to the left of the picture. In the 1940s, The Birmingham Waste Paper Co. Ltd, stood on the site of the cottage in Francis Street. More recently, the site has been used as a garage.

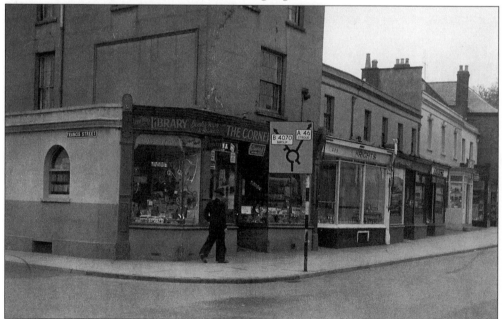

The author's parents purchased The Corner Shop in 1953. This photograph was taken whilst plans were being made to extend and modernize it. At this time, the shop itself was very small. The little room with the small window, in Francis Street, led off from the shop and was used as a lending library. The author remembers Frank Wright, the butcher, next door, and also Excell's, the lovely old-fashioned sweet shop next to the Brown Jug public house.

Work in progress at The Corner Shop,
late 1950s.

The author's mother, Iris Worsfold, standing in
the doorway of The Corner Shop, in the 1960s,
with her assistants, Marion on her left and
Audrey on her right.

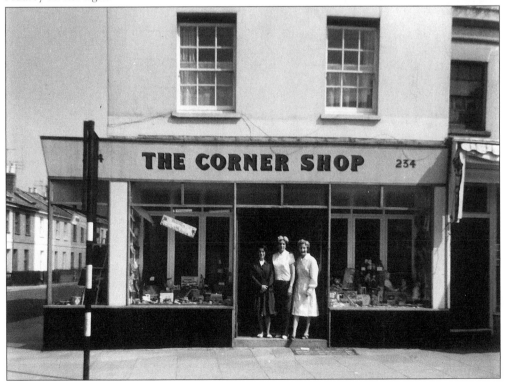

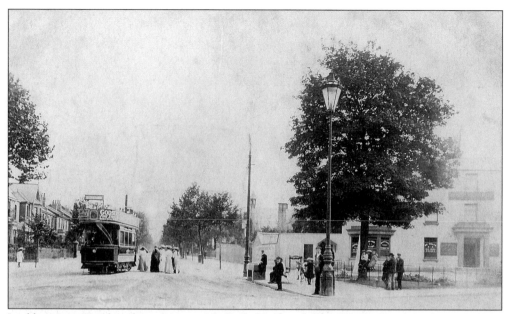

Leckhampton Road at the junction with Bath Road and Shurdington Road, early 1900s. The Norwood Arms public house stands on the corner of Shurdington Road and, further up Leckhampton Road, the old school can be seen. Buses stop nowadays where tram number 6 is picking up its passengers. The animals' drinking trough is still in this spot today, but is used for impressive floral displays.

The corner of Brandon Place and Tryes Road, looking towards the Shurdington Road, winter 1962. The author's father, Bill Worsfold, operated a wholesale stationery business, trading as W. J. Norman & Co. Ltd. He purchased this corner plot, comprising a warehouse and yard, formerly used by a builder, and an almost derelict cottage, in March 1962 and adapted the premises for his use, utilizing the cottage for additional storage. The cottage has today been renovated and the warehouse converted for residential use.

W.J. Norman & Co. premises in Tryes Road, 1963. Bill Worsfold is standing on the left, next to the car. Mrs Thorpe, his secretary, is on his right. To the right of the picture are two other members of staff, Mr Slee (on the extreme right) and Mr Jackson. Mr Jackson had worked for the original firm of Frederick Norman as a printer and paper bag maker and when this photograph was taken he was aged ninety-one! The gentleman on the far left is Bernard Avery.

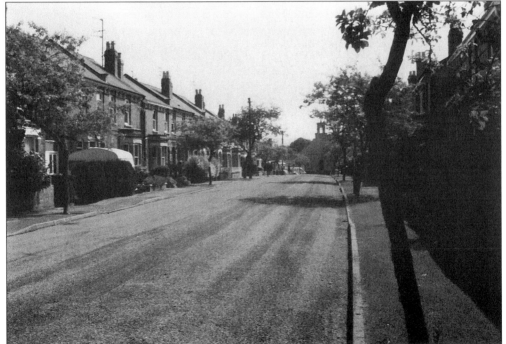

Ewlyn Road, off Leckhampton Road, with no traffic or parked cars, 29 June 1993. This was the day the road was cleared for resurfacing, but it does allow us a clear view through to Emmanuel Church, built in 1936 to replace an earlier building in Naunton Terrace.

A young Mary Heasman outside the family home, Colnville, no. 3, Ewlyn Road, sitting on a stump of one of the lime trees. The trees, planted when the houses were built, had become too large for safety and consequently were all felled in the early 1960s. Irene Popiel, whose father Stefan still lives at no. 7, Ewlyn Road, took the photograph.

The Heasman family purchased no. 3, Ewlyn Road in 1938. This inventory of furnishings, bought from the previous owner of the house for £6 15s 6d, lists stair carpet for the sum of ten shillings. Interestingly, four blankets were more expensive at sixteen shillings.

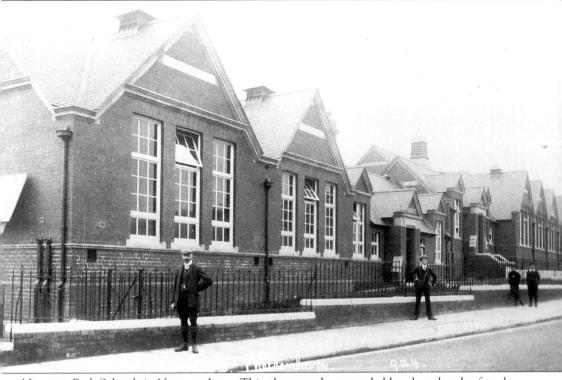

Naunton Park Schools in Naunton Lane. This photograph was probably taken shortly after the schools were built around 1906. In the First World War, the buildings were used as a hospital.

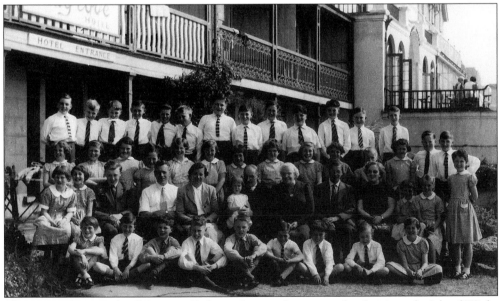

This group photograph of Naunton Park pupils was taken on a school visit to the Isle of Wight in 1957. Amongst the group are Mr Walters (teacher), Mr and Mrs Musson (helpers) and the following pupils including: Patricia Barnes, Andrew Dyke, Linda Jeffries, Lorna Murray, Susan Orpe, Marion Tiller, Elizabeth Turner, Susan Westlake and David Young.

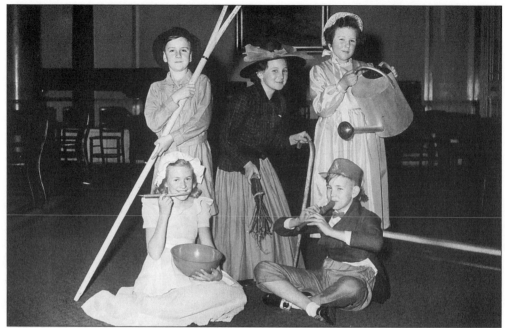

Naunton Park Junior School pupils in the Cheltenham Competitive Festival of Music, Speech, Drama and Dance in 1958. Nursery Rhymes were the theme. The author is in the centre of the photograph, playing the old woman who lived in a shoe. Also in the picture are (seated) Susan Orpe and Peter Butcher and (standing) Nicholas Slader and Valerie Bissett.

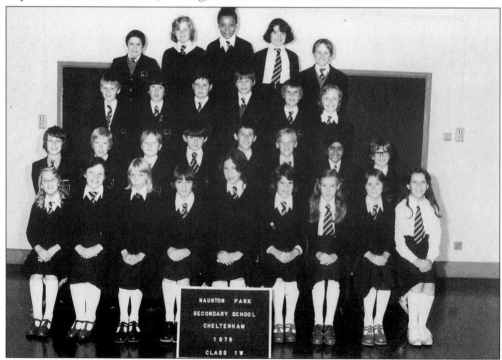

Class 1W pupils, pictured here in 1978, were part of the last intake of children to Naunton Park Secondary School. The school closed in the 1980s.

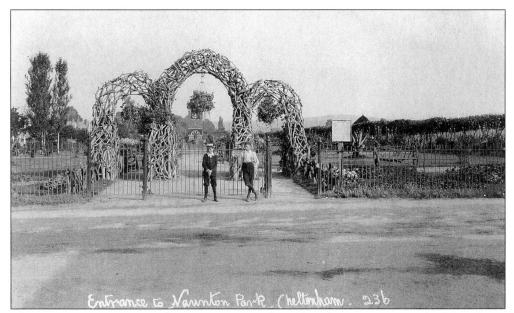

Entrance to Naunton Park, Cheltenham. 236

The entrance to Naunton Park, Naunton Lane. The park and recreation grounds, although not fully completed, were opened on 6 July 1893, the wedding day of the Duke of York and Princess Victoria Mary of Teck (who were, of course, later to become King George V and Queen Mary). Note the words 'NAUNTON PARK' woven into the rustic looking archway and also the top of the thatched roof of the bandstand, just visible in the background. This was used until 1925, when it was removed as it had deteriorated beyond repair.

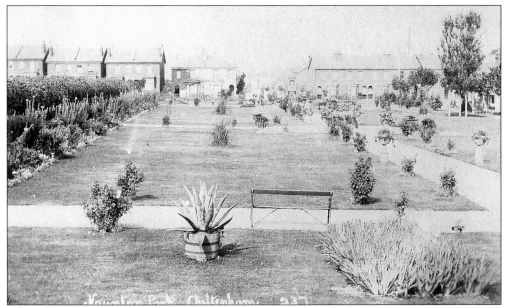

Naunton Park, Cheltenham. 237

Another view of Naunton Park, early twentieth century, looking towards the houses in Naunton Lane. The Hay Memorial Cottage Homes can be seen on the right of the picture. These almshouses were named after their benefactors, John Alexander and Mariane Louisa Hay.

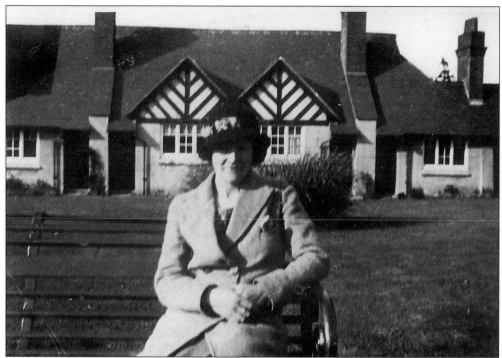

Hay Cottage Homes, Naunton Park, 1930s. The foundation stone of the first cottage was laid on 24 May 1899, as part of Cheltenham's celebrations to mark Queen Victoria's eightieth birthday. Rose Jakeway is pictured sitting in the gardens.

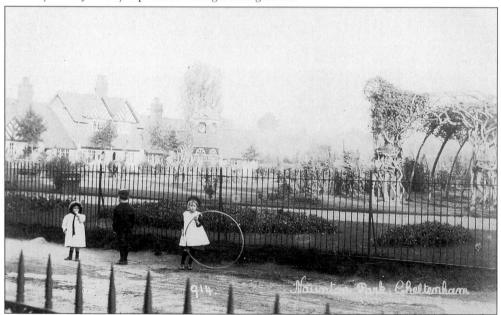

A little girl plays with a hoop outside Naunton Park, early 1900s. In front of the Hay Homes in the background is the drinking fountain, erected in 1894. The unusual design of the fountain was the work of Joseph Hall. It was approximately twenty feet high and comprised of a square brick pillar with Doulton tiles.

Six

Leckhampton and Leckhampton Hill

The Leckhampton quarries were officially opened in 1793 and have played an important part in the history of Cheltenham. Many of the fine buildings in the town have used the local Leckhampton stone. In 1927, Cheltenham Town Council purchased the 400 acre freehold estate, previously owned by the Leckhampton Quarry Co., and in 1929 the mayor officially opened the hill to the people of Cheltenham. Alderman C. H. Margrett declared that 'we shall be handing to posterity a large open space which can be visited by any and every inhabitant of this town'.

No book on Cheltenham would be complete without a picture of the Devil's Chimney. It is a well-known landmark and something of a talking piece. Despite the obvious danger, it used to be quite common to see climbers on the Chimney. Today it is fenced off and, hopefully, will be preserved for at least another century.

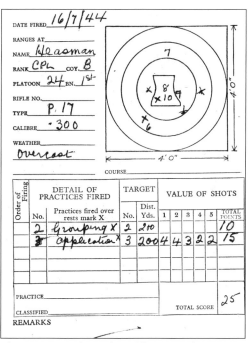

In May 1940, a Battalion of the Local Defence Volunteers was formed in Gloucestershire. 'B' Company was essentially a village unit, incorporating volunteers from Leckhampton, Naunton Park, Charlton Kings, Holy Apostles and, initially, Prestbury. Platoon 24 had been set up in the Naunton Park area, but became the Smith Gun Platoon. The above extracts are taken from a 1st Gloucester Battalion Home Guard range scoring book belonging to Cpl Ted Heasman of Elwyn Road.

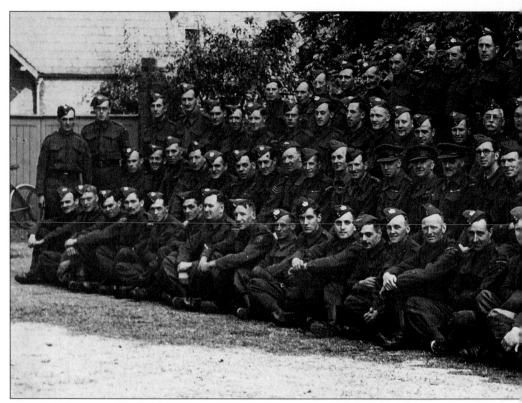

Almost 100 men from 'B' Company, pictured here at The Withyholt, Moorend Road, Charlton Kings, in 1944. Ted Heasman is seated in the front row, fifth from the left. Ted was in a reserved occupation – the publication and distribution of daily newspapers – and started the working day at four in the morning. Other Platoon 24 members included: a timber-feller, hotel maintenance

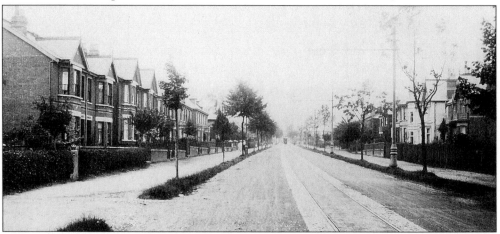

The Bath Road and the Shurdington Road were developed in the early nineteenth century. By 1859, the part of the Leckhampton Road which linked the Bath Road with the existing road above the Malvern Inn was completed. This photograph, taken around 1910, is a view of Leckhampton Road looking towards the Malvern Inn and the junction with Church Road. The second house on the right is Glengariff, which was built in 1905. Electric street lighting did not reach Leckhampton until 1912.

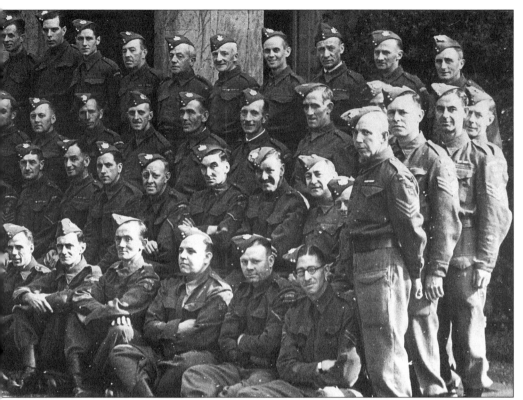

staff, a plasterer and various turners, fitters and inspectors engaged in the aircraft industry. These men worked, on average, sixty-hour weeks in their daytime occupation, but still went to train, perform guard duty or man roadblocks from dusk till dawn.

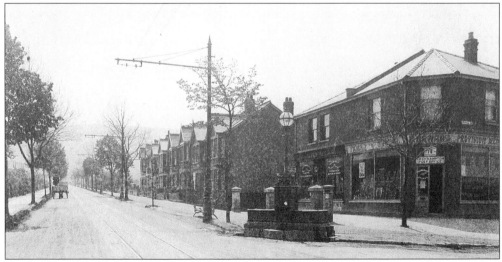

Leckhampton Road, from the junction with Church Road, early 1900s. Leckhampton Hill can be seen in the background. The village post office still stands on this corner, together with a general store. The postbox also remains on the same spot today. In contrast to this scene of a lone horse and cart travelling up Leckhampton Road, bollards have recently been erected at the junction in an attempt to slow down the traffic.

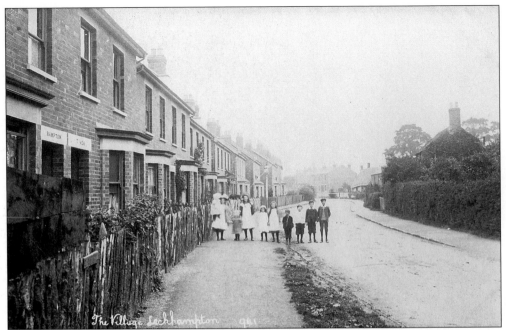

This lovely card, produced by Norman Bros around 1900, of impeccably dressed children posing in the road for their photograph, is simply titled 'The Village, Leckhampton'. It is actually a view taken in Hall Road, looking towards the school and the junction with Church Road. The allotments are situated on the right of this picture.

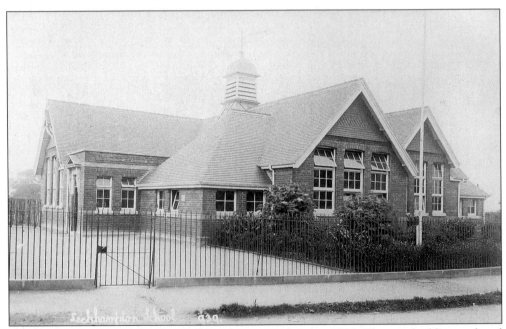

Leckhampton Primary School in Hall Road was completed in 1906. The new building replaced the former village school on the corner of Church Road, which had been built around 1840 by the Revd Charles Brandon Trye, rector of Leckhampton for fifty-three years. Today, the school has been considerably extended to cope with the growing number of children in the area.

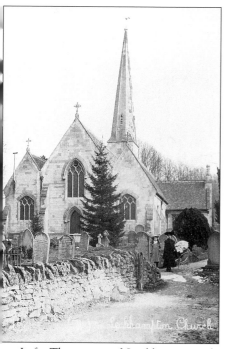

Left: The tower of Leckhampton church closely resembles that of Cheltenham's St Mary's parish church. In the churchyard is a monument to Dr Edward Wilson. He was a local man and spent much of his childhood at The Crippets, Leckhampton. Right: The lych-gate at the entrance to St Peter's, Leckhampton, was built in 1893. The occasion here is the christening of Gary Smithers, the author's nephew, in 1964. Left to right: Bill Worsfold, Marjorie Bubb, Alan McKie, Betty McKie (née Widdows) with Gary, Cindy Smithers, Dick Bubb, Roland Bubb, Iris Worsfold, Dorothy 'Dolly' Smithers, Len Smithers, the author and Geraldine Smithers.

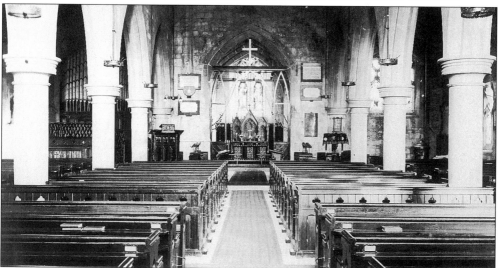

An early view of the interior of Leckhampton church. Many extensions to the church have been carried out over the years, the original Norman church being considerably smaller. The church contains many memorials, mainly of the Norwood and Trye families, their histories so intricately entwined with each other's.

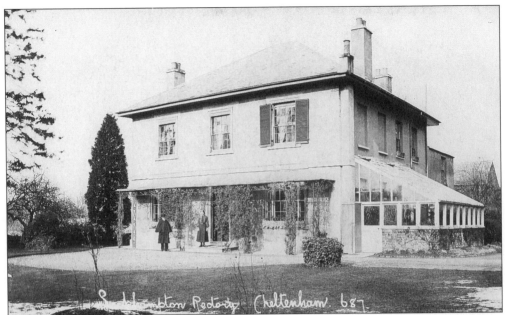

Leckhampton Rectory. Cheltenham. 687

It is believed that the Revd Charles Brandon Trye was responsible for the building of The Rectory in 1830. The Revd Reginald Edward Trye, Rector of Leckhampton from 1884, was born here in 1843. He died in 1928 and was buried at Leckhampton. He started the Parish Magazine in 1888. The building, situated opposite Leckhampton church in Church Road, is easily recognisable today.

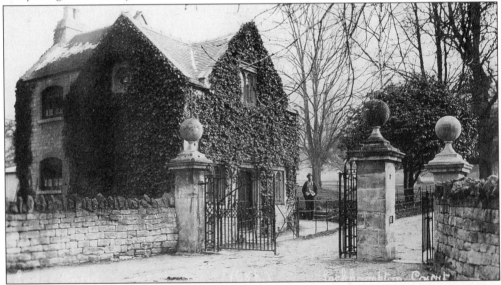

Three famous families: the Giffords, the Norwoods and the Tryes, have all owned Leckhampton Court. The history of its ownership is complex, as on several occasions there has been no male heir to carry on the title. In 1894, the entire estate of 400 acres – comprising the building itself, the village, the hill and the quarries – was divided and sold. Today, the Court is owned by the Sue Ryder Foundation and has been for more than twenty years. The lodge building, featured in this photograph, is still standing today, but without much of its ivy, the gate pillars and the fine iron gates.

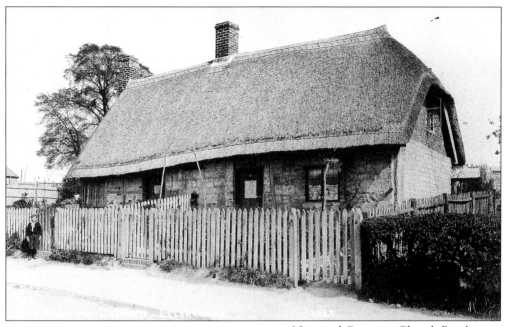

Norwood Cottages, Church Road, Leckhampton, early 1900s. These cottages formed part of the 1894 auction of the Leckhampton estate and were sold for £175. The rent for one of these cottages at this time was £5 10s 0d per annum.

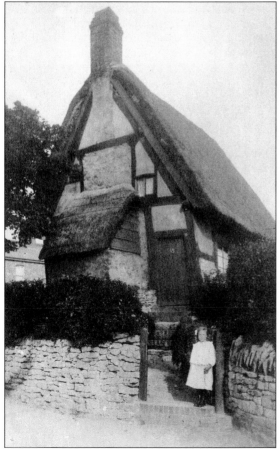

Cromwell's Cottage stood at the junction of Church Road and Hall Road and dated back to the fifteenth or sixteenth century. In the 1960s, the cottage was demolished. Two bungalows were later built on this site.

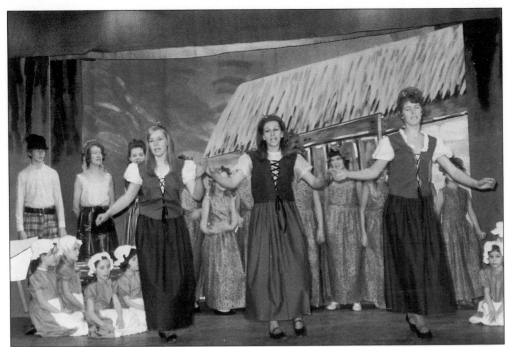

Two scenes from a Leckhampton Players production of *Puss in Boots*, 1970. Above: Sara Harwood is centre front and Jean Mitchell to the right. Below: Cindy Smithers is standing second from left. The Leckhampton Players celebrated their fiftieth anniversary in 1997.

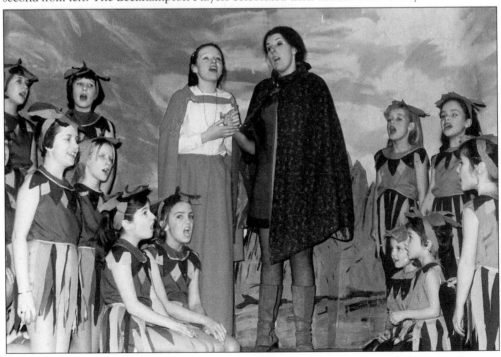

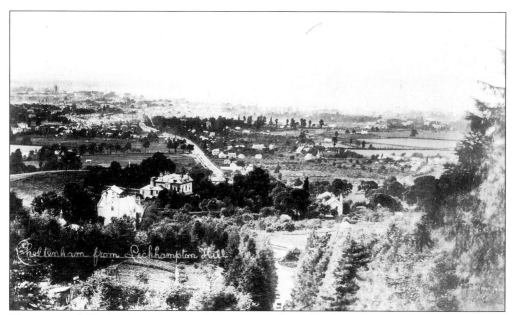

This view of Cheltenham from Leckhampton Hill is dated 14 January 1911. The lack of development at this time is evident, especially on the lower slopes of the hill.

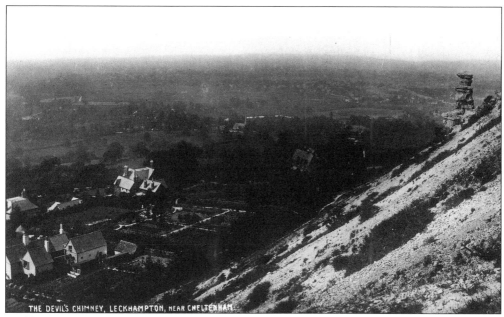

Leckhampton Hill, showing the Devil's Chimney, in the 1900s. The hill inspired the late P.F. Gunnell to write the poem *Leckhampton Hill*, one of his first group of poems, written between 1952 and 1954. The poet ascribes these words to the hill, 'How sad she looks tonight./Long flanking hill./Crouched a tired lion./Sleepy old sentinel, under the touch of the sun'. Peter Gunnell was born in Penarth, near Cardiff, in 1925 and was educated in Cheltenham.

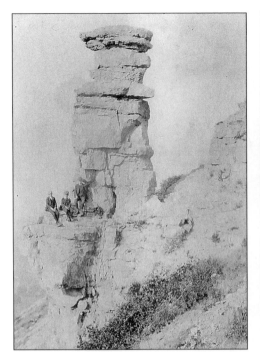

Left: Three young men sitting on The Devil's Chimney, from a card posted in 1910. The Chimney is thought to have been man-made and was probably created around 1780, presumably by quarrymen. In 1985, Cheltenham Borough Council carried out repairs to the chimney, costing £25,000. Right: The Chimney, with Cheltenham in the background, October 1962. The author and a schoolfriend, Carol Lewis, pose for the photograph.

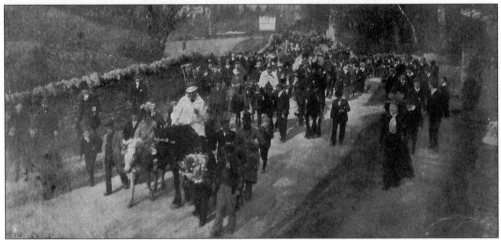

Leckhampton Hill, Disputed Rights of Way Procession, Good Friday, 1902. At the sale of the Leckhampton estate in 1894, John Henry Dale of Daisybank House, director of a well-known piano merchants in Cheltenham, bought the hill. He intended to make money by building on it as well as continuing to quarry. By 1900, Salterley Quarry had re-opened and was doing well. However, Dale upset the local people by restricting access to the hill. He built Tramway Cottage, which blocked footpaths that had been used for centuries. The Town Clerk failed to respond to complaints and, in 1902, the people rioted. Some men were arrested, but later acquitted.

Seven

Charlton Kings

In the thirteenth and fourteenth centuries, arable farming brought prosperity to the hamlets in the area now known as Charlton Kings. During this time, there was a big demand for grain and large quantities were exported from Gloucester between 1380 and 1410.

In later years, Charlton Kings provided much of the labouring workforce for Leckhampton and Cheltenham. Residential development in the area was greatly stimulated by the introduction of electric trams to Charlton Kings in 1903.

In 1974, Cheltenham's boundaries were extended to include Charlton Kings in an enlarged Cheltenham district.

Hundreds of Cheltenham children over the years will have received nursery schooling at Mrs Golesworthy's in the Old Bath Road. The first four photographs in this section span a decade (1965-1975) and represent some of these children. The Barnes brothers are in the back row of this photograph. The taller girl is Cindy Smithers, aged four years old. In the front row, fourth from the left, is Heidi Wakeman. Both Cindy and Heidi's families emigrated to Australia in the early 1970s – many local families took up offers of assisted passage around this time.

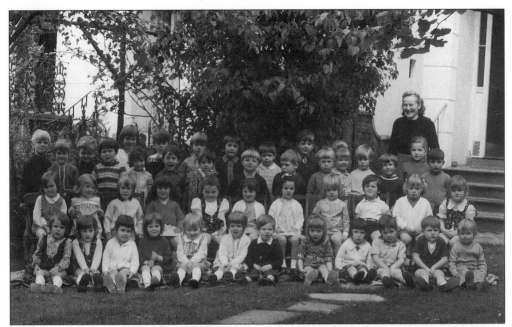

Mrs Golesworthy's pupils, at the front of no. 17, Old Bath Road, 1972. Paula Hyde, at four years old, is the little girl, sitting fourth from the left, in the second row. Claire Lucy is standing second from the left.

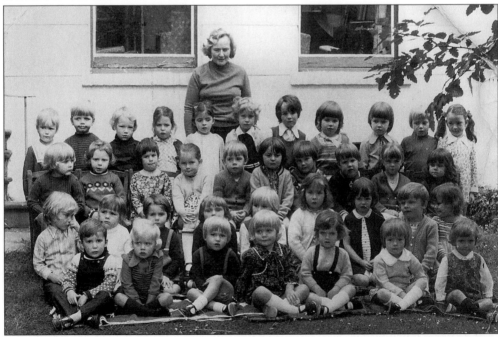

Mrs Golesworthy's pupils, 1973. Tammy Cooper is sitting, second from the left, in the front row. Joanne Woodward and Lisa Hudson are sitting second and third from the right, in the same row. Behind Lisa is Lucy Fairclough. Tammy, Joanne and Lucy stayed together throughout their schooldays, until the age of sixteen, initially at Holy Apostles primary school and then Charlton Kings Secondary School (which later became Balcarras School).

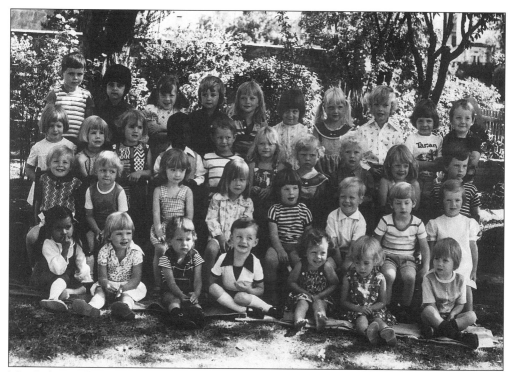

Mrs Golesworthy's pupils, 1975. This lovely picture was taken on, what appears to be, a glorious summer's day. It includes a young Paul Woodward, brother of Joanne, sitting in the second row, second from the left.

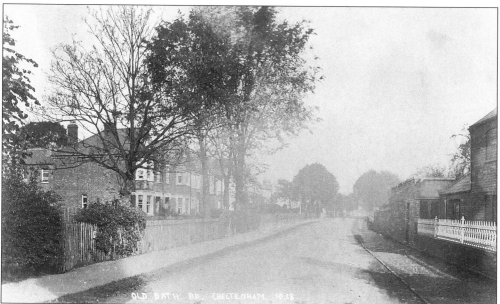

The Old Bath Road, just below the junction with Mead Road. The Old Bath Road was created under the 1784 Act, which allowed the trustees 'to improve Pilford Lane from the Direction Post at Bembridge Field (near Cheltenham) through Birdlip, to join the Turnpike Road from Gloucester at, or near, Painswick'.

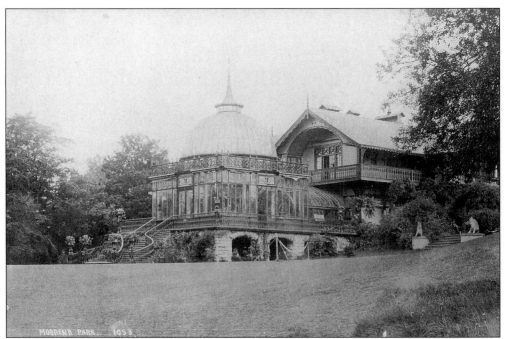

Moorend Park, Moorend Road, Charlton Kings. This view and the one below, are Norman Bros postcards. Moorend Park was built between 1835 and 1840 by Frind Cregoe Colmore, a Birmingham businessman. The original design was by J. B. Papworth. Colmore opted for a Swiss exterior. The building was demolished in 1979.

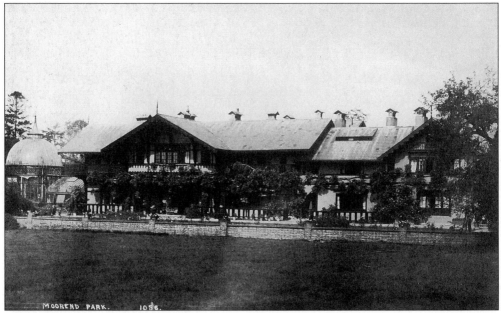

A different view of Moorend Park. In the 1920s, Moorend Park became a hotel. In an advertisement from a later Cheltenham Spa guidebook, it is described as being AA three-stars and RAC rated and as 'Standing in its own grounds of fourteen acres' with 'Central Heating, Tennis Court, Putting Green, Lock-up garages rooms, 25 rooms, 15 with Private Bath'.

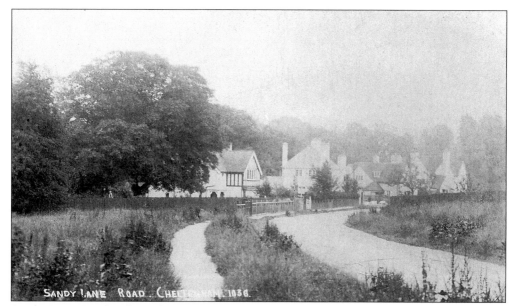

Sandy Lane Road, off Sandy Lane. This is still a peaceful, private residential road today, although there are now more houses than can be seen in this Norman Bros postcard. The first two houses on the left of the picture are The Cottage and Woodend.

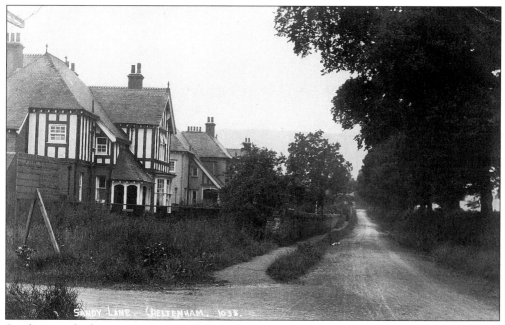

Sandy Lane, looking towards the hill from the junction with Sandy Lane Road. The timbered house on the left is Kitscroft. The rather overgrown corner plot has recently been built upon. Sandy Lane is one of the oldest roads in Cheltenham and once formed part of the old road to Cirencester and London.

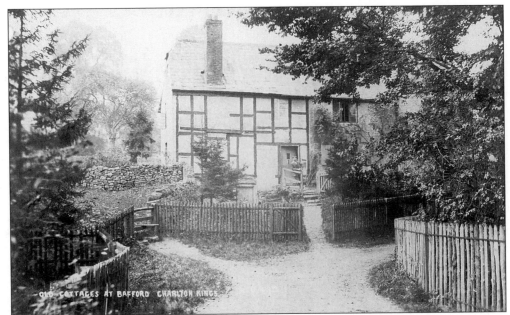

Cottages in Bafford Lane, off Cirencester Road. These date back to the seventeenth century and possibly earlier, as a mill existed here in 1585. Later, the buildings became part of Bafford Farm.

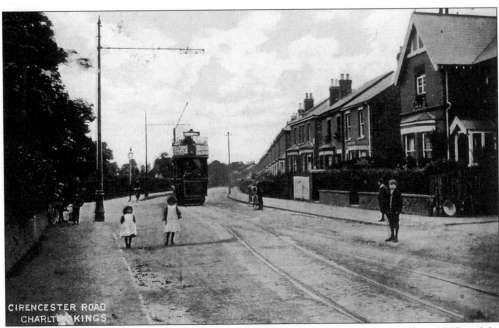

Cirencester Road, at the junction with Pumphrey's Road, from a card posted in 1907 to Mrs Clarke, 3 Buckle's Row, Charlton Kings. The message on the card reads 'Dear Granny, we are sending this card to wish you a happy birthday. When are you coming to see us?[…]Good-bye, Winnie'. The introduction of electric trams in 1903 encouraged development along Cirencester Road.

Official List of Accommodation.

Name and Address	Tel. No.	No. of rooms	Bed and Breakfast	Weekly Terms Full Board
LICENSED.				
BELLE VUE HOTEL, High Street	3454	50	from 17/6	——
IRVING HOTEL, Bath Road	3083	30	18/- to 25/-	7 gns. to 10 gns.
LANGTON HOTEL, Bath Road	2929	42	17/6	7 gns. to 8 gns.
LANSDOWN HOTEL, Lansdown Road.	2700	16	from 16/6	from 7 gns.
LILLEY BROOK HOTEL, Charlton Kings.	5861	32	21/-	10 gns.
MAJESTIC HOTEL, Park Place	2210	60	17/6	7 gns. single 13 gns. double
MOOREND PARK HOTEL, Charlton Kings.	2352	25	from 16/6	7 gns.—10 gns.
MORAY HOUSE HOTEL, Parabola Road.	53613	40	18/-	from 6 gns.
NEW INN, Gloucester (9 miles)	Glos. 22177	40	18/-	£8 15s. 0d.
PLOUGH HOTEL, High Street	2087	55	18/6	
QUEEN'S HOTEL, Promenade	3013	100	from 23/-	from £12 5s. 0d.
ROYAL HOTEL, High Street	4732	45	14/6	7½ gns.
SAVOY HOTEL, Bayshill Road	5149	45	from 16/6	from 7 gns.
THIRLESTAINE HALL HOTEL, Thirlestaine Road.	5821	50	27/6	10 gns. to 14 gns.
FLEECE HOTEL, High Street	2364	50	14/6	£8 1s. 0d.
RAILWAY HOTEL, Ambrose Street	2860	16	from 12/6	——
RISING SUN HOTEL, Cleeve Hill (3½ miles).	Cleeve Hill 2	18	from 15/6	7 gns.
ROYAL GEORGE HOTEL, Birdlip (7 miles).	Witcombe 2106	12	16/6	from 5½ gns.
STAR HOTEL, Regent Street	2856	12	14/-	7 gns.

The Cheltenham Spa guidebook of 1951 (the year of the Festival of Britain) included this list of licensed accommodation in the town, with bed and breakfast prices as well as weekly terms for full board. Both the Moorend Park Hotel and the Lilleybrook Hotel are listed.

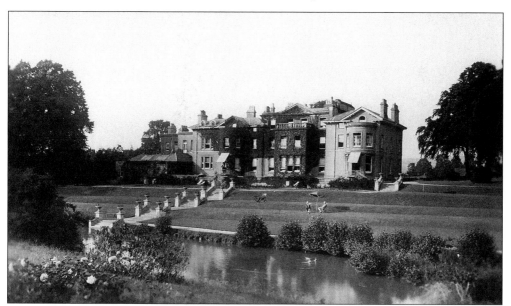

The former Lilleybrook Hotel, Cirencester Road. The Lilleybrook Estate, complete with golf course, was purchased by the Leckhampton Quarries Company shortly after the First World War. Soon afterwards, the house was sold and, following extension and modernization, became the Lilleybrook Hotel in 1922. Later, it was to become the Cheltenham Park Hotel.

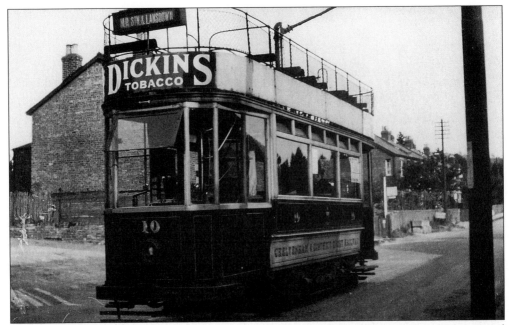

This tram, advertising Dickins tobacco and carrying a sign for Midland Railway Station and Lansdown, appears to be number 10. It is, in fact, tram number 14, which was withdrawn from service in 1927 for modernization and reintroduced as number 10. The tram is travelling along Cirencester Road.

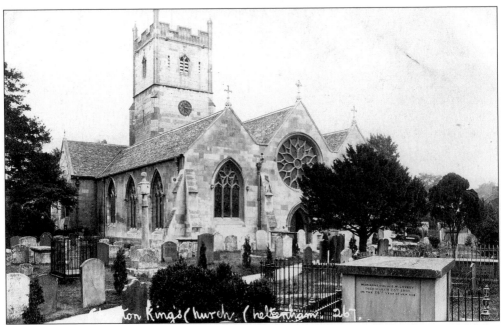

St. Mary's church, Charlton Kings, was built as a chapel-of-ease to Cheltenham's St Mary's parish church and was consecrated in 1190. Much building work has taken place over the years. The central Rose Window was added in 1824.

St Mary's church and the War Memorial, from Horsefair Street, Charlton Kings, 1985. The Memorial has a base of Cotswold stone and was erected in 1920 to the memory of men from Charlton Kings who were killed in the First World War. The lych-gate was also constructed to remember the dead and to celebrate peace.

Teresa Hyde and Lindsay Norris were married at St Mary's Church, Charlton Kings, on 2 May 1987. The bride's sister, Paula Hyde, was bridesmaid. Myra Norris, the groom's mother, is standing to the left of the photograph. In the group are Fred and Alice Hyde, grandparents of the bride, pictured to the left of the groom. On the right are Brian and Brenda Hyde, the bride's parents. Standing next to Brenda is her mother, Lilian Ward.

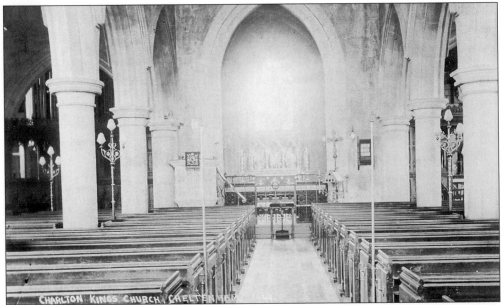

St Mary's church, Charlton Kings, interior, *c.* 1910. Notice the ornamental gas lamps, which were installed when the church was restored in the 1870s; electric lighting was not installed until 1922. These brass standards each had three burners with pink glass shades and remained in use until 1914, when they were replaced by lighting suspended from the arches. The pulpit was carved by Martyn & Emms and was presented to the church in 1877. The intricate ironwork rail was donated by W. Price around 1900.

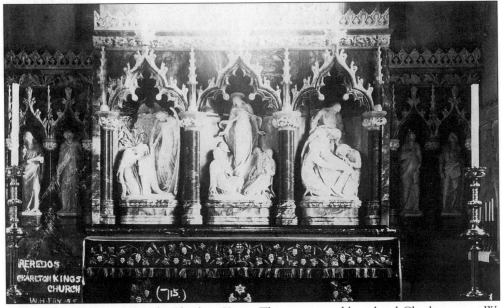

The reredos, St Mary's church, Charlton Kings. This was carved by a local Charlton man, W. H. Fry. The Annunciation, Ascension and Deposition are portrayed, flanked by evangelists, in white alabaster figures and pink marble arches.

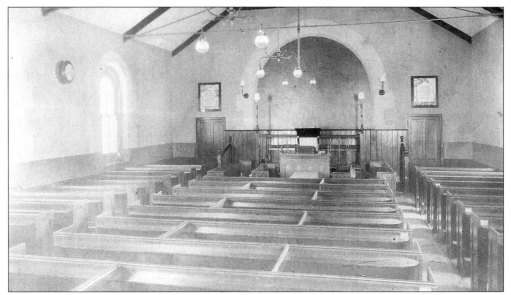

The interior of the Baptist chapel, Charlton Kings, from a postcard sent to Miss Agnes Dent, no. 13, Croft Road, Charlton Kings, with the message, 'sent from the Band of Hope treat Charlton Kings Baptist Chapel Jan 11th 1912'. The chapel was built, towards the end of the nineteenth century, on the site of three cottages in Church Street, by Charlton Kings builder, William Cleevely, one of the five trustees later to become an Elder (subsequently called Deacons). Another trustee was John Lance, the High Street draper. The church had no organ until 1934.

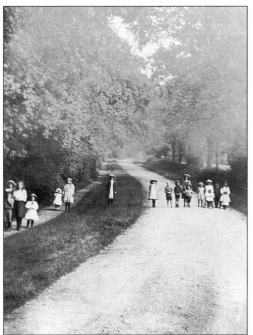

Greenway Lane, early 1900s. This was once part of the old road to London. Under the 1755-1756 Turnpike Act for Cheltenham, the lane was made the responsibility of a turnpike trust. The old pike house stands at the junction of Hewlett Road and Greenway Lane.

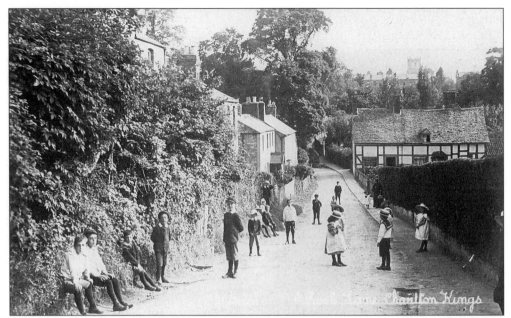

School Lane, off London Road, *c.* 1900. This is another Norman Bros postcard. School Lane is now known as School Road. St Mary's church tower can be seen in the background. Nearly all the children are wearing hats, including some fine-looking straw boaters. One little boy is dressed in a sailor suit, others seem to be similarly clad in smart jackets and crisp white collars, whilst the girls are sporting white pinafores.

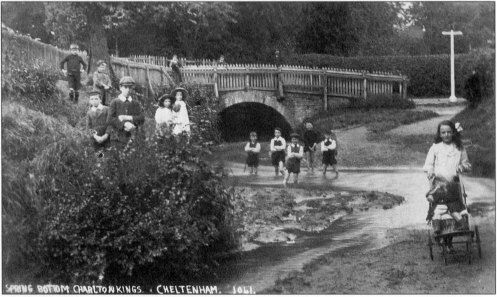

Spring Bottom, *c.* 1900. This picturesque place has been the subject of many drawings and paintings over the years. It is also a favourite spot for children. These children have stopped to look at the photographer, whilst an older sister pushes a smaller child in her pushchair. Charlton (or Cudnall) Mill, which handled corn from Ryeworth, can be traced back to the eleventh century. In the late eighteenth century, a leather mill operated here for a while, before it became a small dairy farm.

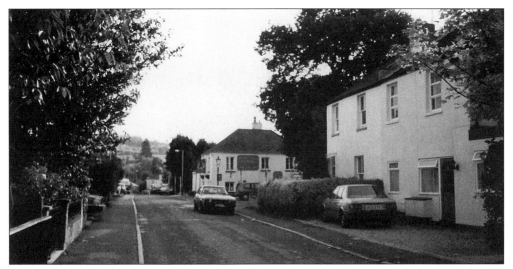

Ryeworth Road looking towards the Ryeworth Inn. The first building on the right used to be the local shop, but was converted into flats when the store closed.

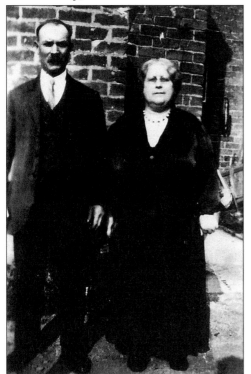

Left: Ernest Jesse and Cordelia Woodward (née Green) at no. 132 Ryeworth Road, early 1900s. At this time, the address would have been no. 5, Melton Terrace, as Ryeworth Road was not numbered until much later. Ernest Jesse was born 16 May 1880, in Ryeworth, and worked as a stonemason for Boulton's, Wellington Street, Cheltenham. Right: Balcarris Lane, now known as Balcarras Road, off East End Road, around 1900. This is a very rural view, which has changed little over the years. However, nowadays, at the bottom of the road, is Balcarras School and Sports Centre.

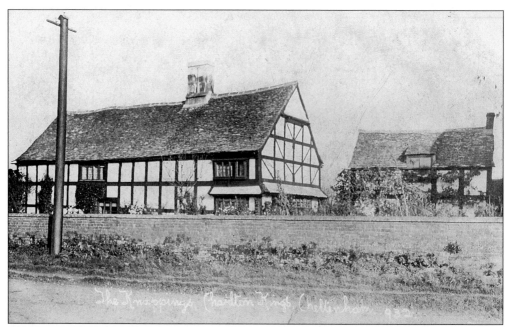

This fine, timbered building described as The Knappings, Charlton Kings, later became known as The Nappings, Up End. It was the home of the Batten family in the seventeenth and eighteenth centuries. The house is still standing today and can be found on the Cirencester Road, opposite the industrial estate.

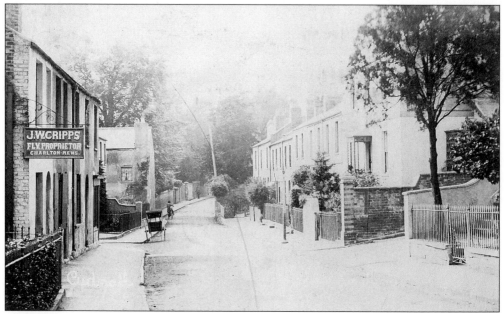

Cudnall Street from the London Road. This card was sent as a New Year greeting to Miss Lane of no. 10, St. Philips Terrace, Cheltenham. Posted on 1 January 1914, the message reads 'With best wishes for 1914, A. F. L.'. The shop on the corner of Brookway Road is no longer there. Oakland Street is to the right of the picture.

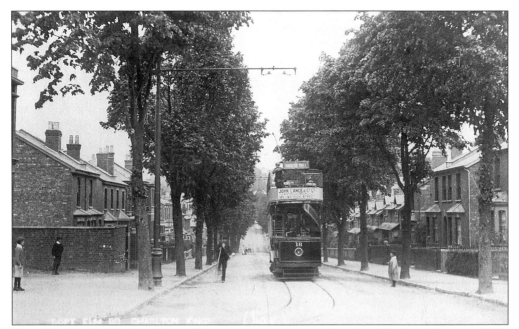

Copt Elm Road, Charlton Kings. Electric trams were introduced to Charlton Kings in 1903. This number 18 tram was delivered to the town in 1905. This tram's route was up to Six Ways, down Copt Elm Road and along Lyefield Road West, to the Cirencester Road. This tram is advertising John Lance & Co. of Cheltenham.

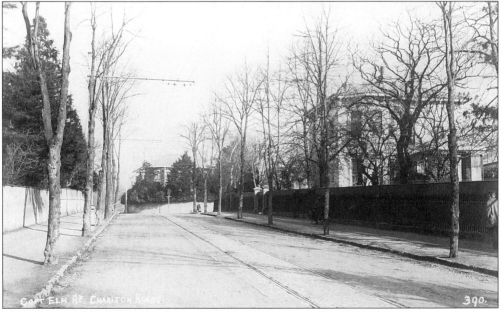

Copt Elm Road, looking towards London Road, c. 1910. Roadlands can be seen in the distance, on the corner of Greenway Lane. Sir William Russell cut Copt Elm Road in 1865, hoping to sell building plots for good prices. The house on the right, Lexham Lodge, was one of the first to be built here.

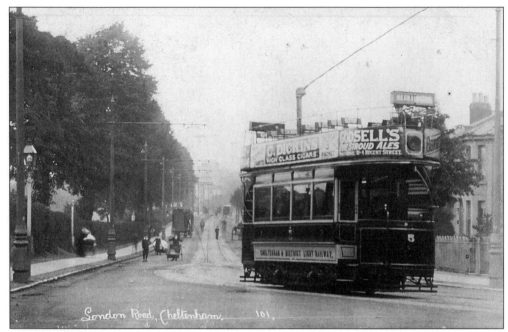

Number 5 tram is one of the original trams from 1901 put into service in Charlton Kings in 1903, seen here travelling up the London Road at the junction with Cirencester Road. C. Dickins, the tobacconist, and Godsell's Stroud Ales, are advertised on the safety boards around the upper deck.

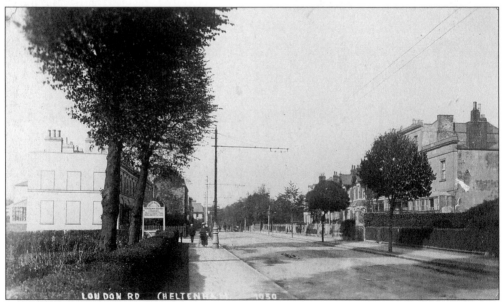

A view looking down the London Road towards Cheltenham. The junction with Sandford Mill Road can be seen on the left. Wayside, the large house now standing on the corner with Sandford Mill Road, was built in 1912, after this photograph was taken.

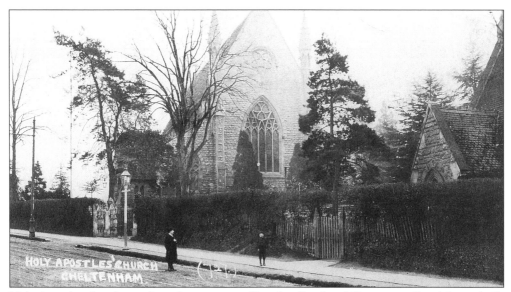

Holy Apostles church stands at the junction of London Road and Cirencester Road. It was built between 1866 and 1871 in Leckhampton stone. The land was donated by Charles Cooke Higgs in 1862, who eventually shouldered all the building costs of £7,000 himself, due to a lack of public support. Holy Apostles School , seen on the right of this photograph, opened for boys in 1873 and girls in 1874. The school later moved to a new site.

Above: This view shows the elaborate interior of Holy Apostles Church in the early 1900s. The carving work by Boulton & Sons was outstanding. Sadly, part of the church was later damaged by fire. Above Right: It is difficult to believe that Sam Woodward of London Road, christened at Holy Apostles in July 1977, has just celebrated his twenty-first birthday! The vicar in the photograph with Sam is the Revd Patrick Walton.

Holy Apostles infant school children on the school playing field, 1975. Miss Lazenberry, a helper at the school, is in the centre of the group. Amongst the children are, front row: Sarah Cordell, Vicki Jones, Fiona Holland, Melissa Todd, Vicki Henderson, Tammy Cooper, Elizabeth Price, Joanne Woodward, Lisa Hudson. Second row: Elizabeth Butcher, Colin Upton, Michelle Reeves, Sian Parry, Lisa Baynes, Penny Chilver, Joanne Winstone. Third row: Samantha Dibden, Debbie Hyland, Melanie Chilver, Jacqueline Hall. Fourth row: Christopher Stanley, Simon Davis. Back row: Tracy Keen, Shaun Roberts, Paul Sheen.

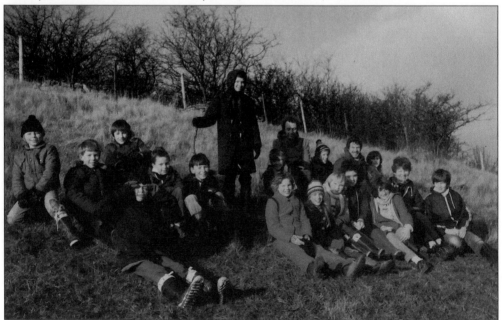

A group from Holy Apostles junior school on Cleeve Hill in the early 1980s. The group was accompanied by Bob Shayler, a teacher. Bob used to take children to the hill regularly during the Christmas holidays. Included in this group are Ewen Jones, Andrew Tombs, Roger Poole, Paul Woodward, John Cumming, Jason Poole, Olivia Clark, Jane Nicholls, Bethan Willis, Kathy Robins and Emma Baldham.

Eight
Prestbury

Prestbury was a market town in the seventeenth century and many of its fine old buildings and cottages can be traced back to this period. In 1930, only about 2,000 people lived in the village. Over the next fifty years, housing developed, factories were built and the population increased threefold. In 1991, Prestbury was brought into the Borough of Cheltenham, following a boundary change.

I lived in Prestbury as a child and have fond memories of the village. It was very different then. There was normally little traffic to be seen, except on race days, when as children we would stand and watch the queues of cars in amazement, I was christened in St Mary's church and went to Sunday School here. My sister, Geraldine, attended Prestbury School and remembers good times spent with the local youth club as a teenager in the 1950s.

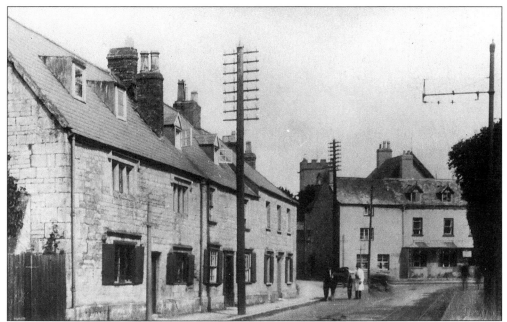

Deep Street, looking towards the High Street, early 1900s. The tower of St Mary's Church can be seen in the background. The picture shows the tracks for the electric trams which, from 1901, ran through the village to Cleeve Hill. The three houses on the left can be traced back to the sixteenth century and are thought to have been used as the infirmary for the monastery.

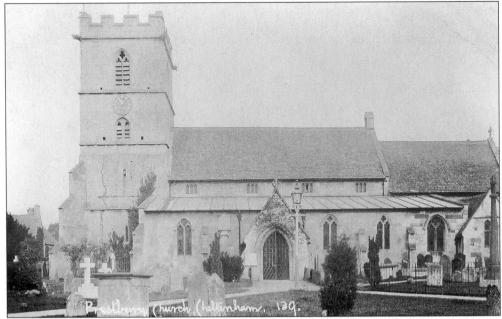

St Mary's church, c. 1900. The railings were removed for salvage in the Second World War.

In August 1959, Revd Norman Kent writes that once again a printing dispute is preventing the publication of the parish magazine. One of the main issues this month was the death in July of one of Prestbury's fondly-remembered personalities, Felix Sumption, who was the Prestbury postmaster for fifty years, from 1909 until 1959. His mother, Mary, was postmistress before him for thirty-six years. His father, George Sumption, acted as sub-postmaster, whilst continuing to work as a bookbinder.

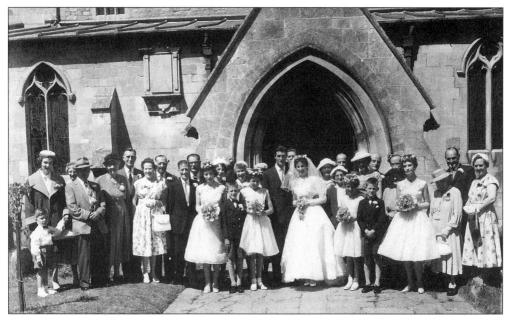

The wedding of Geraldine Iris Worsfold and John Alfred Smithers, St Mary's church, 4 July 1959.

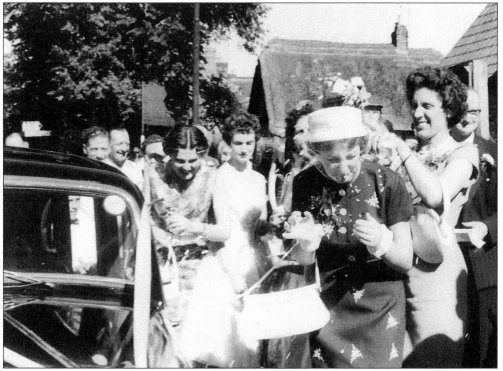

The reception was held in the Women's Institute Hall, Prestbury Road. Iris Worsfold, the bride's mother, is showering the happy bride with confetti. In the background is the thatched roof of Randall's Cottage, Bouncer's Lane, which dates from the early seventeenth century.

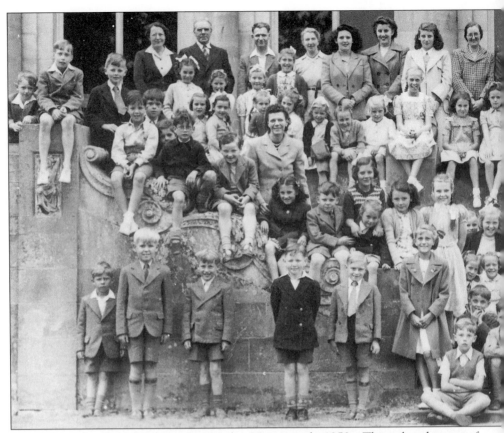

St Mary's Sunday school outing, Cowley Manor, early 1950s. This relaxed group of children, arranged around Father Hill, includes Janet Cox, Rosemary Dunn, Hazel Lovesey, Diana Parker, Eileen Parker, Rosemary Parker, Louise Pockett, Sylvia Roberts, Anita Robinson, Jackie Russell, Ann Smith and Geraldine Worsfold. Father Speakman, Mrs Bowen, Miss Phillips, Mrs Kate Parker and Miss Winnington-Ingram, are among the adults standing at the back.

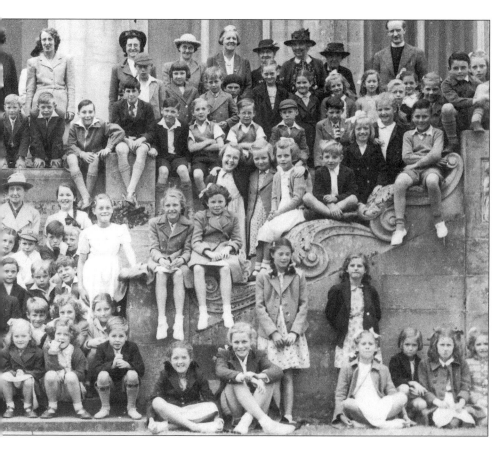

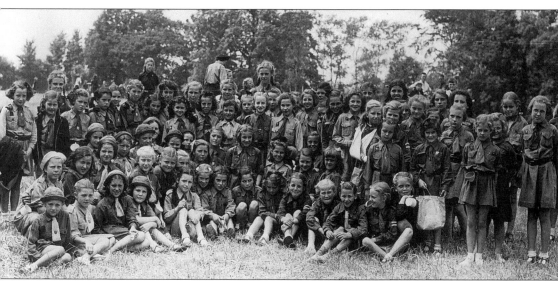

A happy group of Brownies, *c.* 1950. Included are the following girls from Prestbury: Wendy Collins, Rosemary Dunn, Janet Howe, Diana Parker, Eileen Parker, Louise Pockett, Ann Smith, Geraldine Worsfold. Jamborees such as this one were held in the grounds of Prestbury House (now the Prestbury House Hotel), then owned by Major Christopher Capel.

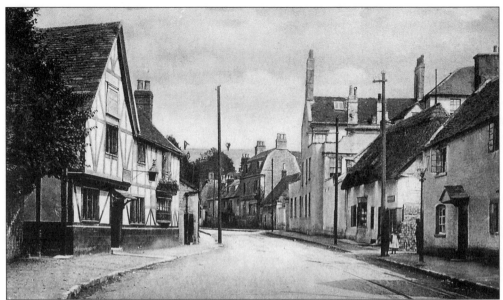

High Street, Prestbury, *c.* 1905. The writer of this postcard refers to the doctor's house, at the top of the picture in the trees, the King's Arms public house, on the left, and Robinson's cake shop, on the right. Tramlines are clearly visible on the deserted roadway. Emma Hayward, eldest daughter of the landlord of the Kings Arms, married William Archer, who was the father of champion jockey Fred Archer (and a famous jockey himself, having won the Grand National in 1858 on 'Little Charley').

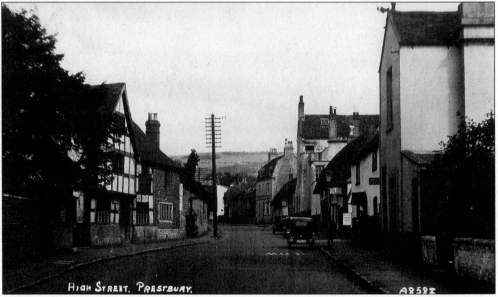

High Street, Prestbury, *c.* 1934. A more modern view of the High Street with parked motor cars and 'Slow' road markings. A public telephone is now available for use and the King's Arms sports a new sign. Next to the King's Arms, where the car park is today, the old stone-built St Mary's church hall can be clearly seen. The Prestbury Home Guard trained in this hall in the 1940s. It was also used as a youth club and as an overflow classroom by St Mary's School, in the 1950s.

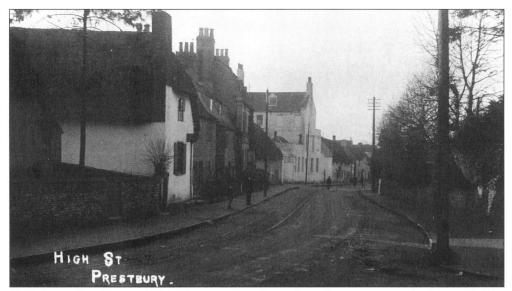

High Street, Prestbury, *c.* 1900. This was taken from where the war memorial now stands. The white-painted thatched cottage, on the left, later become the grocer's shop run by Mr and Mrs Preece, the author's godparents, for nearly thirty years. The thatch was removed in the 1960s.

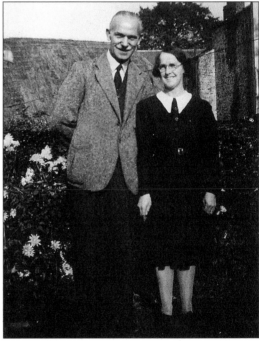

Left: The author *c.* 1949. This was taken in the back garden of the thatched cottage (shown above). The wooden shed housed an outside toilet. In the garden there were steps down to an underground cellar, where the cheese was kept and at the bottom of the garden was the wash-house. Right: Ted and Louisa Preece (née Pearce) continued to run the grocer's shop until they retired and moved to Glebe Road in the 1950s. Mrs Preece is remembered for the tales she used to tell of the ghost she had seen across the fields from the shop, later referred to as 'Mrs Preece's ghost'. This apparition is said to haunt Mill Lane.

These photographs, both taken around 1915, show a young Ted Preece in naval uniform and Louisa Pearce, sporting a hairstyle fashionable at that time.

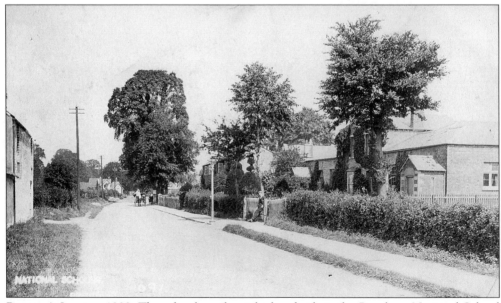

Bouncer's Lane, *c.* 1900. The school on the right-hand side is the Prestbury National School (its name changing to Prestbury Church of England School in 1906). Opposite the school was a piece of land used as a school garden. Ann Kear (née Smith) remembers playing rounders on this field in around 1950, before it was sold and the new Church Hall erected on the site in 1955.

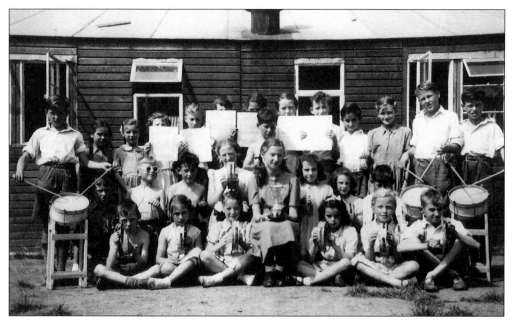

Prestbury School band, 1948, proudly displaying a trophy won at the Cheltenham Competitive Music Festival held in the town hall. Amongst those in the picture are Rosemary Dunn, Janet Howe, John Miller, Barbara Smith, Ann Thomas, Roger Thorndale and Geraldine Worsfold. The wooden huts were used as additional classrooms.

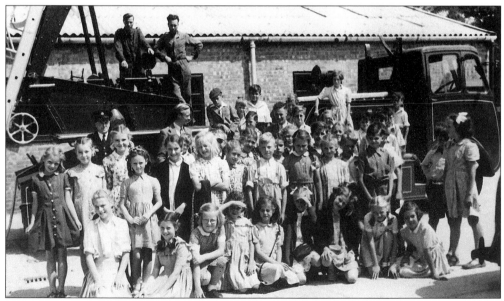

Prestbury School outing to the fire station in Cheltenham, 1949. In this group with Mr Harrison (teacher) are: Janet Cox, Janet Howe, Hazel Lovesey, Pat Newman, Diana Parker, Eileen Parker, Clive Pope, Anita Robinson, Jackie Russell, Ann Smith, Ann Thomas, Jenny Wilding and Geraldine Worsfold.

No. 83, Bouncer's Lane, 1945. The author lived here as a child. Winnie Mitchell, sitting at the front of the house, served in the Land Army during the Second World War. The author's father purchased the hammock (a luxury at the time) in the back garden, from Cavendish House, where he was working before the war.

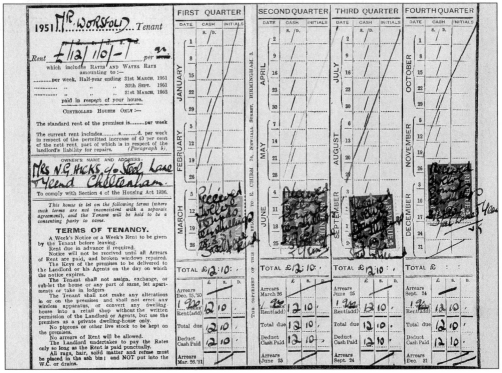

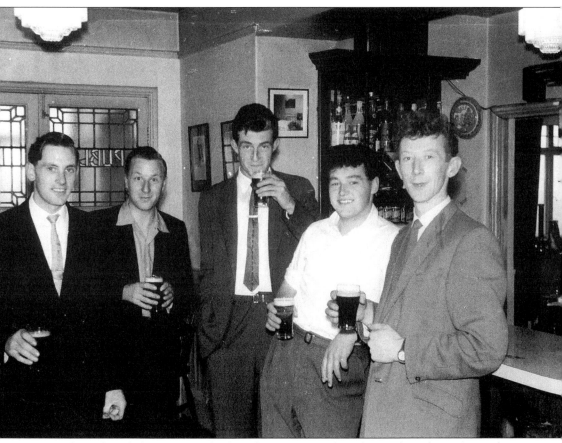

A group of Prestbury lads enjoying a drink at the Corner Cupboard, Winchcombe. Left to right: Mike Newman, Brian Vick, John 'Jack' Smithers, Tony O'Shea, David 'Birdie' Brown.

Opposite: These three bedroom semi-detached houses in Bouncer's Lane are typical of those built in the 1930s and originally sold for less than £1000. Cheltenham was expanding at this time as several larger firms were offering employment and people, such as the author's parents, came to the area hoping to find work. The majority took rented accommodation. The extract above shows the quarterly rent for no. 83, Bouncer's Lane in 1951 as being £12 10s 0d.

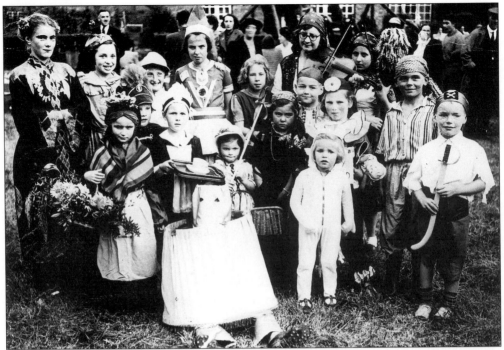

Glebe Road, August 1945. This is a VE Day fancy dress party. The photograph was provided by John Smith (who is standing front-right dressed as a pirate). Also in the group are Brian Gooch, Jennifer Gooch, Janet Mann, Christine Smith, Barbara Smith, Janet Smith, Betty West and Geraldine Worsfold.

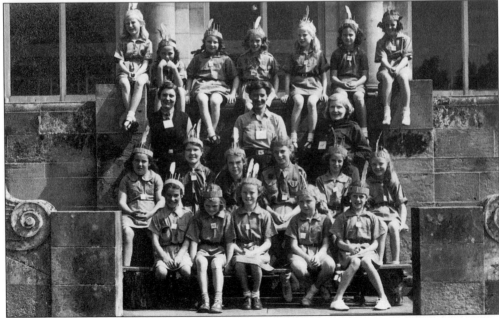

Another group photograph taken at Cowley Manor, a popular place for outings in the 1950s. These Prestbury Brownies, including Wendy Collins and Diana Parker, appear to be having fun in their Red Indian head-dresses.

Nine

Cleeve Hill and
The Racecourse

At the turn of the century, trams brought Cleeve Hill within reach of the people of Cheltenham. Cleeve Hill is the highest of all the Cotswold Hills and technically a mountain at 1083 feet (330m). The Stockwell Common viewpoint informs the visitor that the Malvern Hills can be seen eighteen miles in the distance.

Cheltenham races were first run on Cleeve Hill in August 1918, becoming an annual three-day event. For a number of years there were arguments over the use of the Common for the exercising and racing of horses. In 1831 the race meeting moved to Lord Ellenborough's Prestbury Park. Cheltenham now boasts one of the most beautiful and important racecourses in the country, famous, of course, for the Cheltenham Gold Cup.

As a child, it was a Sunday afternoon treat to drive to Cleeve Hill. More often than not, we would not be able to park on the main road itself, which would mean continuing on up to the junction, turning left and parking along Bushcombe Lane, which I much preferred.

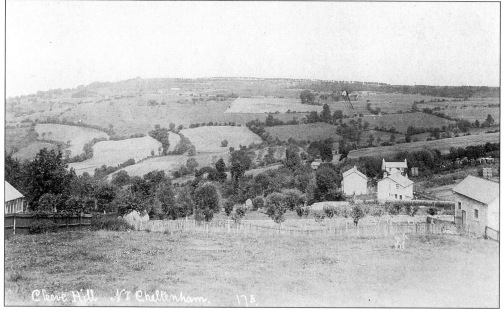

Cleeve Hill. Nr Cheltenham.

Many small farms, such as this one, on the lower slopes of Cleeve Hill have now disappeared.

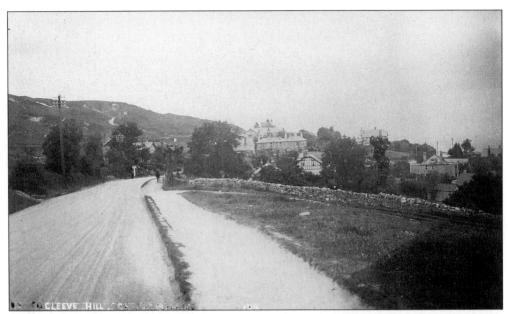

Cleeve Hill became a popular place to live at the beginning of the twentieth century. Much building work took place, including the construction of a number of hotels and rest homes.

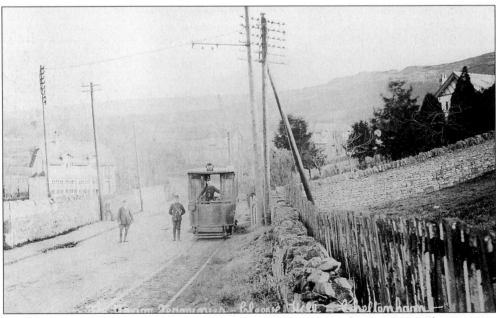

The Tram Terminus, near the Malvern View Hotel, from a postcard sent in 1906. Electric trams ran between Cleeve Hill and Cheltenham from late 1901 until 1929. The number 10 tram was a single-deck car, brought into service in 1903 for use on Cleeve Hill.

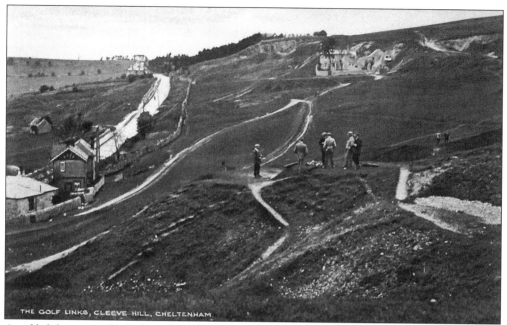

THE GOLF LINKS, CLEEVE HILL, CHELTENHAM

A golf club was established on the hill in 1890. The first course, of three miles, was laid out on the lower slopes close to the road.

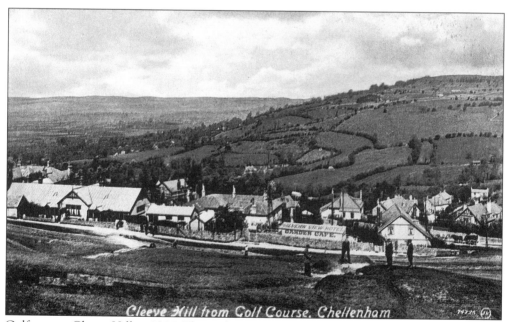

Cleeve Hill from Golf Course, Cheltenham

Golf course, Cleeve Hill, c. 1914. The Malvern View Hotel Garden Café is in the centre of the picture. No doubt this was a welcome sight for the many visitors to the hill following the advent of the trams. On the left is the golf clubhouse.

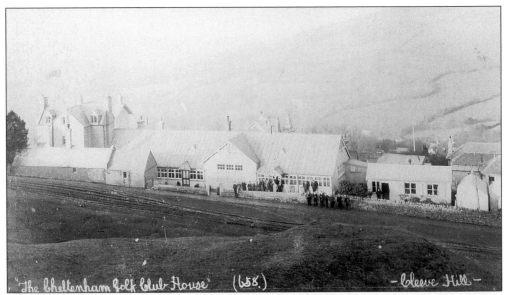

The Cheltenham Golf Club clubhouse, early 1900s. The club lost much of its popularity in the 1920s when the Lilleybrook Golf Club was formed. The Cheltenham Golf Club folded in 1936 and the buildings were converted into a youth hostel.

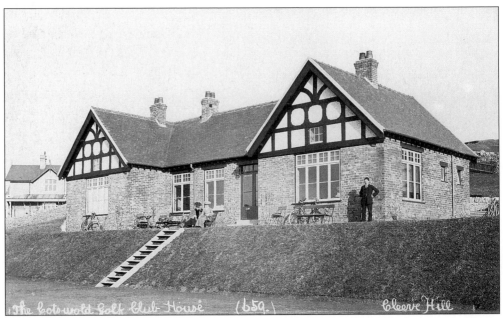

The clubhouse, from the road.

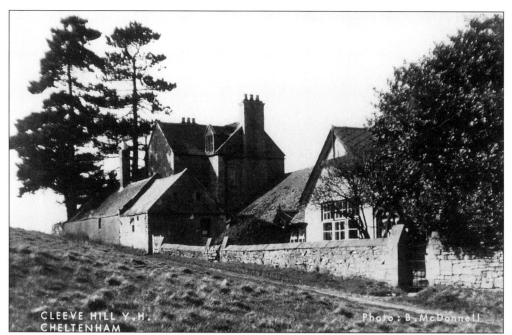

Rock House youth hostel, Cleeve Hill. This was described in a 1959 guidebook as being 'Housed in the old golf club house high up on the western edge of the Cotswolds with uninterrupted views westwards to the Malverns'. These lovely buildings are no longer in use as a hostel and are now in a sad state of disrepair.

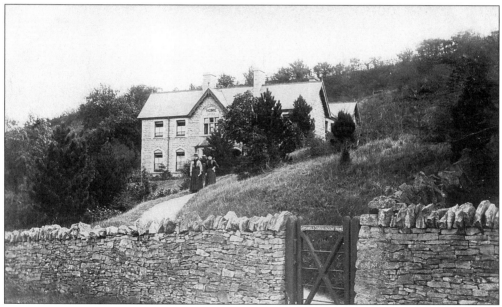

Cotswold Convalescent Home, from a card posted in 1909. This institution was opened in a disused quarry in 1893, as a charity that helped Cheltenham men and women recovering after receiving free hospital treatment. Originally, it was closed during the winter months. In the First World War the home was used by the military and, in November 1914, housed sixteen Belgian soldiers. The home was later extended and is now the Cleeve Hill Nursing Home.

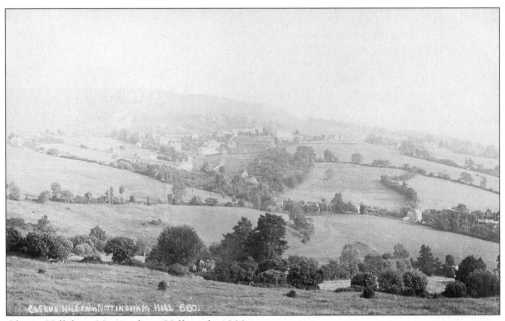

Cleeve Hill from Nottingham Hill, early 1900s.

Ted Heasman and a friend making their way to the racecourse. This photograph was taken before the Second World War.

This press tag was provided by Brian Lee, racing correspondent from South Wales. 1982 was the year that Cheltenham Racecourse was awarded the tenth annual Racecourse of the Year award by the Racegoers Club in recognition of the efforts made by the Racecourse Executives and Staff on behalf of the racing public.

19 ○ 82
CHELTENHAM NATIONAL HUNT FESTIVAL

ADMIT TO

PRESS CENTRE

This Badge does not admit holder to the Racecourse

No. 55

In 1947, on the first day of this December meeting, Ministry of Fuel and Power officials checked the cars bringing racegoers for authorised use of petrol allowances. Daily admission charges, including taxes, at this time were approx. 30s 0d to the Reserved Enclosure and Paddock, 10s 0d to the Public Stand and Enclosure and 5s 0d to the Course.

6d. **Official Programme.** **6d.**

Published by authority of the Clerk of the Course by

Pratt & Co.

CHELTENHAM

DECEMBER MEETING, 1947,
Tuesday & Wednesday, December 30th & 31st.
Under National Hunt Rules.

SECOND DAY.

PATRON:
The LORD BICESTER.
STEWARDS:
H. A. CLIVE, ESQ., M.C.
F. E. WITHINGTON, ESQ., C.B.E.
STANLEY HOWARD, ESQ.
Lt.-Col. R. H. A. GRESSON.

Handicapper—Capt. R. H. HAWKINS.
Starter—Major K. ROBERTSON. *Judge*—Mr. C. A. ROBINSON.
Clerk of the Scales—Mr. F. WOOD.
Clerk of the Course—Mr. E. E. ROBINSON,
9, St. George Street, Hanover Square, London, W.1.
Medical Officers—Mr. H. SANDEMAN ALLEN, O.B.E., F.R.C.S., and
Dr. J. HOWELL.
Veterinary Surgeons—Mr. T. J. BRAIN, M.R.C.V.S., and
Mr. J. L. BRAIN, M.R.C.V.S.
Auctioneer—Mr. C. R. WIGNEY.
Secretaries and Stakeholders—
Messrs. PRATT & CO., 9, St. George Street, Hanover Square, London, W.1.

6d. **6d.**

6th Race **2 miles and a few yards** Armlet: BLUE

3.30.—THE MALVERN NOVICES' HURDLE RACE (Div. 2) of 300 sov.; the second to receive 60 sov. and the third 30 sov. out of the plate; for three-yrs-old and upwards which have not won a hurdle race up to the time of closing; three-yrs-old 10st 5lb, four 11st 10lb, five and upwards 12st; a winner, after the time of closing, of a hurdle race to carry 7lb, of two hurdle races, or of one value 200 sov. 12lb extra; entrance 2 sov., and 4 sov. more unless forfeit be declared to Messrs. Pratt and Co., or Messrs. Weatherby and Sons, by December 16th; two miles and a few yards (74 entries, forfeit declared for 18).—Closed November 18th, 1947.

Age st lb

1—Mr M. Freedman ... **KIND REGARDS** 4 12 8 *grey, coral sleeves, qrtd cap*
 ch c Felicitation—Titbit *Nightingall*
2—Mrs C. D. Wilson.............**EPIGRAPH** 4 12 8 *blue, red and yellow hoop,*
 b g Epigram—Cordon *Beeby* *hooped cap*
3—Mr R. Sweeny **FAN GO FOIL** a 12 7 *blue & white stripes, hooped*
 b g Tai-Yang—Nirvana *Walwyn* *cap*
4—Sir Humphrey de Trafford
 CAPE LIGHT 4 12 3 *scarlet and white (qrtd)*
 ch c Signal Light— *I. Anthony*
 Blue Diamond
5—Lord Abergavenny **TOP CASH** 5 12 0 *scarlet, white cross-belts, slvs*
 b g Wavetop—Little Cash *Norris* *and cap*
6—Mr D. C. N. Barker
 BRICKS AND MORTAR a 12 0 *blue and white hoops, white*
 b g Rameses the Second— *Todd* *sleeves, black cap*
 Polangas
7—Mr A. G. Boley.................. **ABANDON** 6 12 0 *grey, yellow hoops*
 ch g Colliers Gorse, *Walwyn*
 dam by Narrator
8—Capt. W. Brown **TIBERDON** a 12 0 *violet, white cap*
 gr g Tiberius—Heldon *Yates*
9—Mr L. G. Creed ... **ANOTHER PIPER** 6 12 0 *red, white and orange hoops*
 b g Piper's Son—Clonkea *Price*
10—Mr G. H. Dowty.........**BLACK MOON** 5 12 0 *scarlet, green sleeves, hlvd cap*
 b h Precipitation—Merenda *T. F. Rimell*
11—Mr A. W. Fletcher **LEAP MAN** a 12 0 *blue, black trefoil, mauve and*
 b g Salmon Leap— *Houghton* *black qrtd cap*
 Manna's Folly
12—Major Noel Furlong..... **COMERAGH** 6 12 0 *straw, blue sleeves and cap*
 b or br g Brownie— *Private*
 Careless Crag
13—Sir Oliver Goonetilleke **KEIGOR LAD** 5 12 0 *red, blue spots*
 b h Felicitation— *Stephenson*
 The Bittern
14—Miss P. Gosling...... **THE JESTER VI** a 12 0 *white, black cap*
 b g Sailor's Quest—Zerlina *Private*
15—Mr Graham Grant............. **CAVEHILL** a 12 0 *blue, yellow maple leaf, check*
 b h Berwick—Quay Hill *Oxener* *cap*
16—Mr R. Halkett ... **EPISTOLA-GREET** 6 12 0 *pink, black stars, pink cap*
 b m Allagash—Epistola *Hamey*
17—Mrs D. Hartman **PRECENTOR** 5 12 0 *blue and maroon hoops, blue*
 ch g Apron—Orotava *Powell* *sleeves, hooped cap*
18—Mr E. Bee **PADDING** 5 12 0 *white, scarlet sleeves, collar,*
 br h Fair Copy—Pack Ice *Perry* *sash and qrtd cap*
19—Mr F. F. Jesson.........**THE LYNSKEY** a 12 0 *red, white armlets & hoop on*
 b g Tetrator—Lady Sunning *Hollis* *cap*

(Continued on next page)

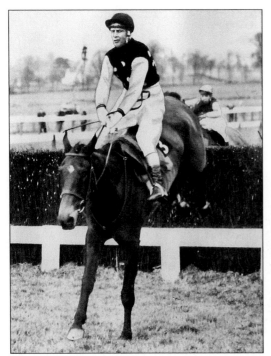
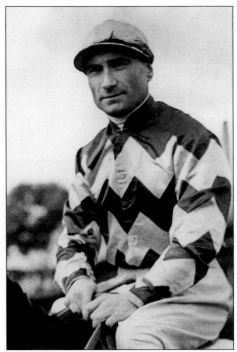

Left: Pat Taaffe rode thirty-two winners at Cheltenham before retiring from the saddle in 1970. Here he is photographed winning the National Hunt Chase in 1966 on 'Arklion'. 'Arklion' and the famous 'Arkle', were both sired by 'Archive'.

Right: David Lewis Jones was born in Llanelli in 1907 and, at eighteen, was apprenticed to the Cheltenham trainer Ben Roberts. In 1945, when racing at Cheltenham was resumed after a two-year break, he won the Cheltenham Gold Cup on Lord Stalbridge's 'Red Rower'.

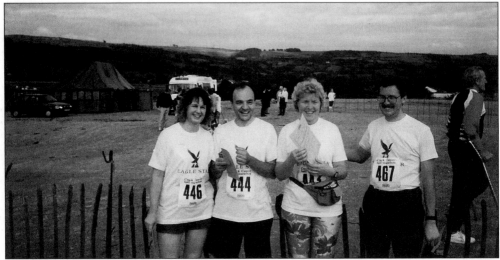

The racecourse has always been used for a variety of functions and events. In 1992, the half-marathon, held to raise funds for the local Crack Cancer Campaign, had its finishing point here. Tired, but justifiably proud of their achievement and pictured with their certificates are, from left to right: Chris Gleeson (formerly Fitzsimons), Dave Brick, Veron Woodford and Ian Macrae.